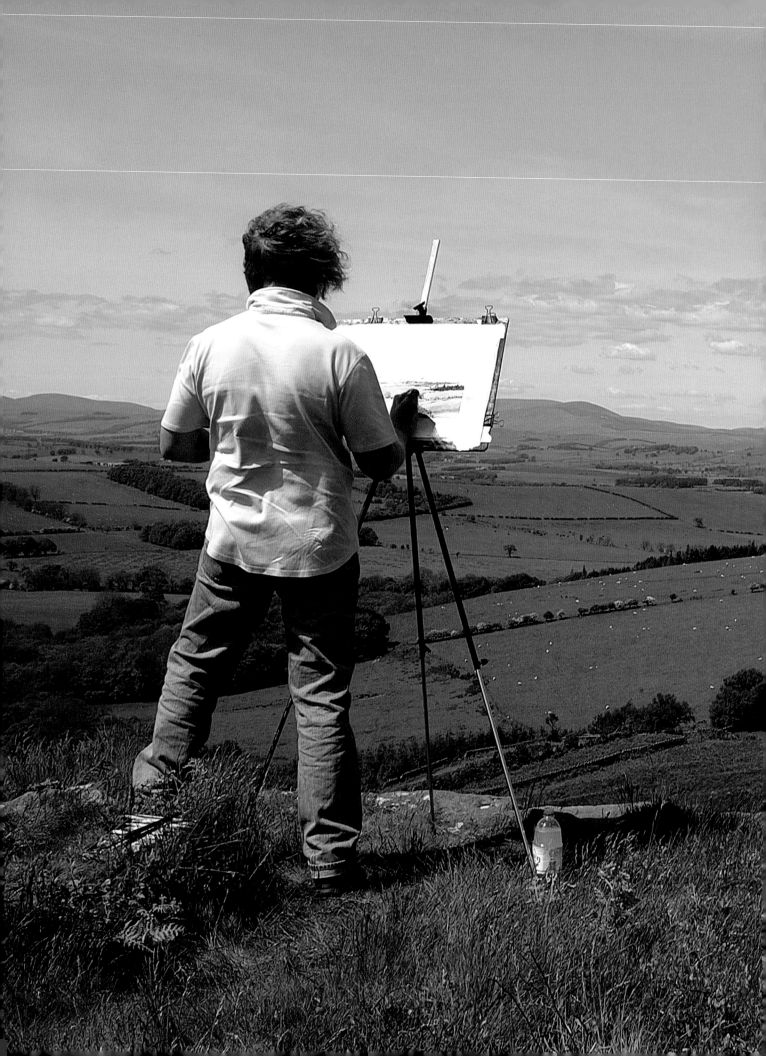

Quick & Clever
WATERCOLOUR PENCILS
Charles Evans

D&C
David and Charles

A DAVID & CHARLES BOOK
Copyright © David & Charles Limited 2006

David & Charles is an F+W Publications Inc.
company
4700 East Galbraith Road
Cincinnati, OH 45236

First published in the UK in 2006

Text and illustrations copyright © Charles
Evans 2006

Charles Evans has asserted his right to
be identified as author of this work in
accordance with the Copyright, Designs and
Patents Act, 1988.

A catalogue record for this book is available
from the British Library.

ISBN-13: 978-0-7153-2283-3 hardback
ISBN-10: 0-7153-2283-4 hardback

ISBN-13: 978-0-7153-2297-0 paperback
ISBN-10: 0-7153-2297-4 paperback

Printed in China by SNP Leefung
for David & Charles
Brunel House Newton Abbot Devon

Commissioning Editor Mic Cady
Project Editor Ian Kearey
Assistant Editor Louise Clark
Senior Designer Sarah Underhill
Production Controller Kelly Smith

Visit our website at www.davidandcharles.
co.uk

David & Charles books are available from
all good bookshops; alternatively you can
contact our Orderline on 0870 9908222 or
write to us at FREEPOST EX2 110, D&C
Direct, Newton Abbot, TQ12 4ZZ (no
stamp required UK only); US customers call
800-289-0963 and Canadian customers call
800-840-5220.

Dedication

This book is dedicated to my long-suffering
mother. She has a saying, 'When they're young
they break your bank, and when they're older
they break your heart'; I must have done both
many times, but still she makes the pilgrimage to
my studio to do the catering on all my courses and
to generally look after me and my clients. For this
and millions of other things, Mother, thank you.

Contents

Introduction

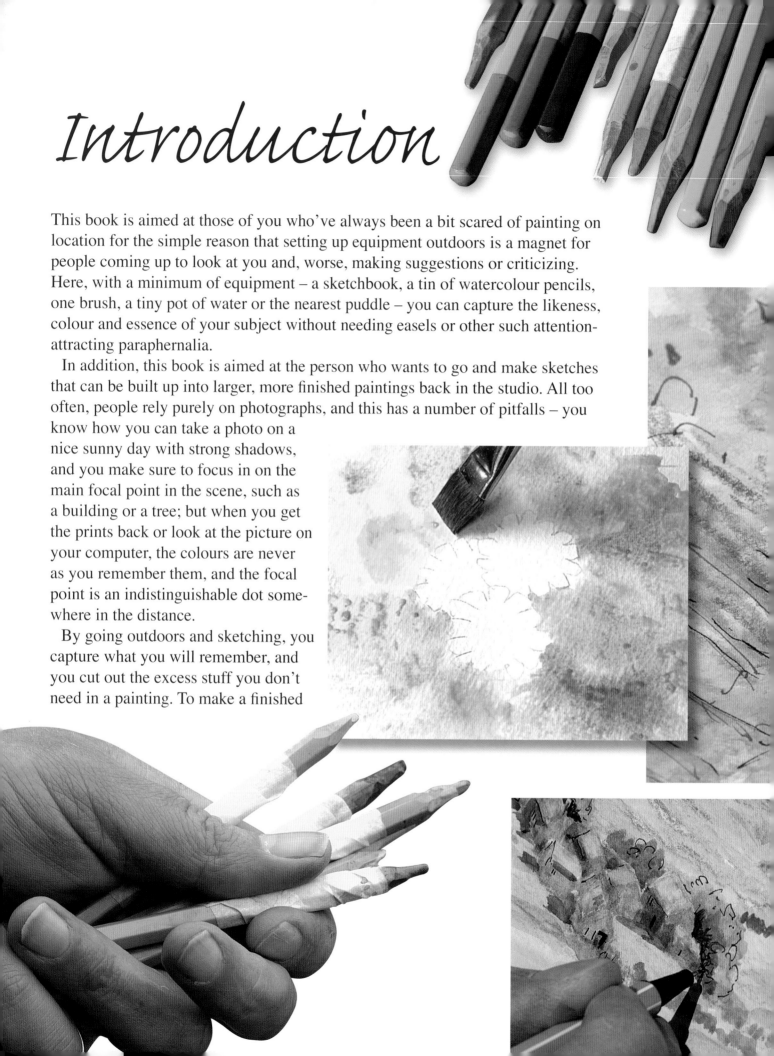

This book is aimed at those of you who've always been a bit scared of painting on location for the simple reason that setting up equipment outdoors is a magnet for people coming up to look at you and, worse, making suggestions or criticizing. Here, with a minimum of equipment – a sketchbook, a tin of watercolour pencils, one brush, a tiny pot of water or the nearest puddle – you can capture the likeness, colour and essence of your subject without needing easels or other such attention-attracting paraphernalia.

In addition, this book is aimed at the person who wants to go and make sketches that can be built up into larger, more finished paintings back in the studio. All too often, people rely purely on photographs, and this has a number of pitfalls – you know how you can take a photo on a nice sunny day with strong shadows, and you make sure to focus in on the main focal point in the scene, such as a building or a tree; but when you get the prints back or look at the picture on your computer, the colours are never as you remember them, and the focal point is an indistinguishable dot some-where in the distance.

By going outdoors and sketching, you capture what you will remember, and you cut out the excess stuff you don't need in a painting. To make a finished

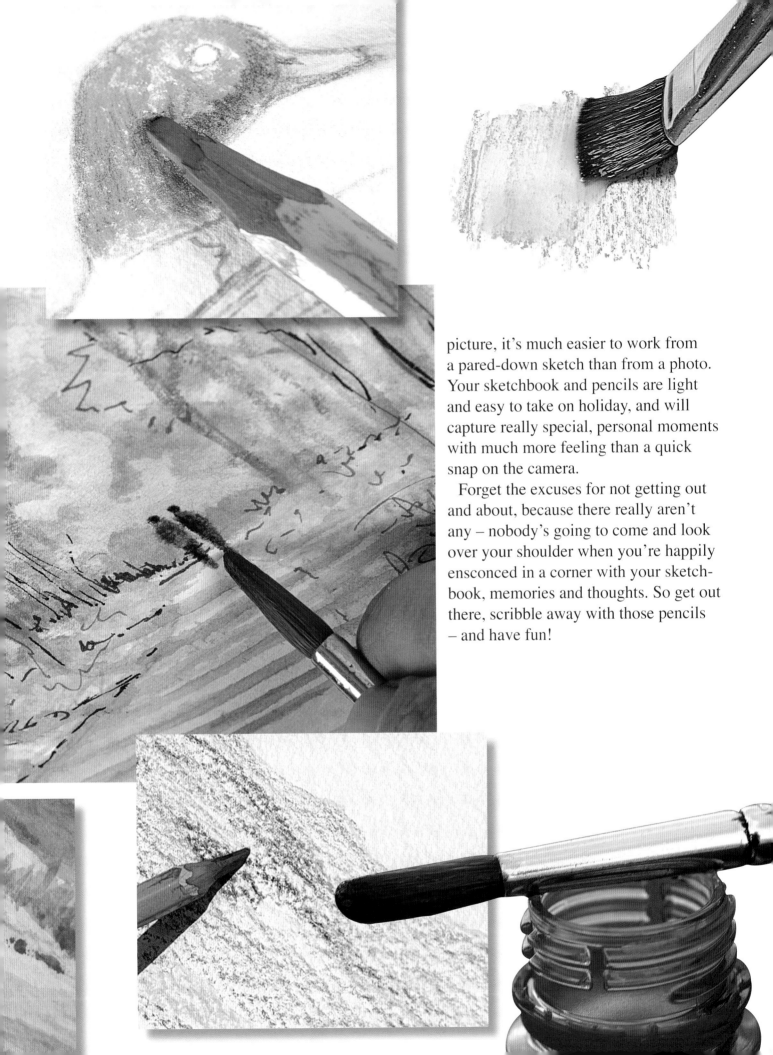

picture, it's much easier to work from a pared-down sketch than from a photo. Your sketchbook and pencils are light and easy to take on holiday, and will capture really special, personal moments with much more feeling than a quick snap on the camera.

Forget the excuses for not getting out and about, because there really aren't any – nobody's going to come and look over your shoulder when you're happily ensconced in a corner with your sketch-book, memories and thoughts. So get out there, scribble away with those pencils – and have fun!

Tools and Techniques

Materials

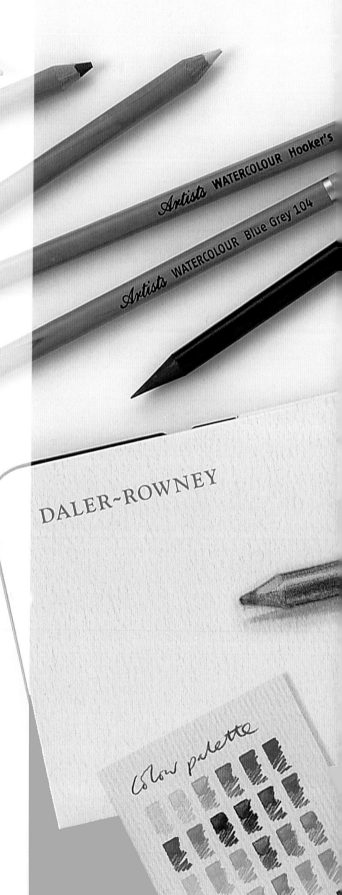

Pencils

The pencils I use are Daler-Rowney's range of high-quality watercolour pencils, which use very strong artists'-quality pigments. As you'll see in this book, I don't use a huge amount of different colours, but the pencils aren't expensive and it's nice to have a particular colour for when you need it, even if this is once a year.

A very important thing to remember with watercolour pencils is that if you use a penknife or craft knife to sharpen them – *not* a pencil sharpener – the points don't become brittle or snap easily, and thus last a lot longer.

For sketching outdoors, a useful tip is to wrap a bit of masking tape around the pencil where your fingers hold it: this stops the pencil getting any sweat off your fingers on a hot day or moisture from the atmosphere on a wet one, both of which can make the pencil slip around alarmingly. You can see that I've done this for the projects in this book.

I don't use an eraser, because if you make a mistake in your outline drawing – as I frequently do – remember that the pencil is a watercolour one; all you have to do is stroke water over it, and the offending line vanishes!

Brushes

As I said in the Introduction, one of the great joys of working with watercolour pencils is that you don't need a lot of equipment. My main brush for making sketches on location is a No. 8 round Sapphire, which is a fine blend of best-quality sable and synthetic material. For working on larger projects and more finished pictures I also use a ¾in (19mm) flat wash brush, also Sapphire.

Paper

Watercolour pencils are versatile and can be used on a variety of surfaces. On the whole I tend to use a hardback sketchbook that contains best-quality acid-free cartridge paper. Even though this paper can buckle a bit

Dark 354

Artists GRAPHITE HB

Artists GRAPHIC 8B

Artists WATERCOLOUR Cadmium

Artists WATERCOLOUR Cadmium

Artists WATERCOLOUR Cadmium

Artists WATERCOLOUR Yellow Ochre 663

Artists WATERCOLOUR Perylene Red 529

Artists WATERCOLOUR French Ultramarine 123

Artists WATERCOLOUR Cadmium Yellow (Hue) 620

36 Artists' watercolour pencils

DALER~ROWNEY

Artists WATERCOLOUR Cadmium Yellow (Hue) 620

12 Artists' watercolour pencils

colour palette

when I add water to the drawings, it ends up perfectly flat when it dries, as you can see from the sketchbook pages dotted throughout this book. These sketchbooks are available in many sizes; I use A4 ones.

In addition to having hardback sketchbooks, I specify that they are string-bound as opposed to glued – the paper is always good in these quality sketchbooks, and you won't lose pages full of memories and sources of reference because they become unglued and fall out. Most of my sketchbooks don't even have covers any more, as they've been bashed around so much on my travels, but the pages are fine and hold the pencil colours perfectly.

You can also use watercolour pencils as a painting medium on all watercolour paper surfaces: I use 300gsm (140lb) Rough-surface Langton paper. As you can see in the projects here, I also use tinted paper for some work; this comes from a pad of Bockingford tinted papers.

Pens

A few pens are useful, and I often use a plain black ballpoint or fine fibre-tip pen; this isn't line and wash work – once the washes are dry, I simply use the pen to make some squiggles here and there to pull out details and firm up some lines.

Water

Most of the time I don't take any water with me on sketching trips – there's always a puddle, a stream or river or the sea, and on early mornings there is dew on leaves and grass: one dip of the brush or pencil, and I'm away! One advantage of staying in most hotels, as I do a lot when touring and giving demonstrations, is the little bottles of cheap shampoo the hotels supply – just pour out the shampoo, rinse out the bottle and fill it, then put it in your pocket and you have a day's worth of water.

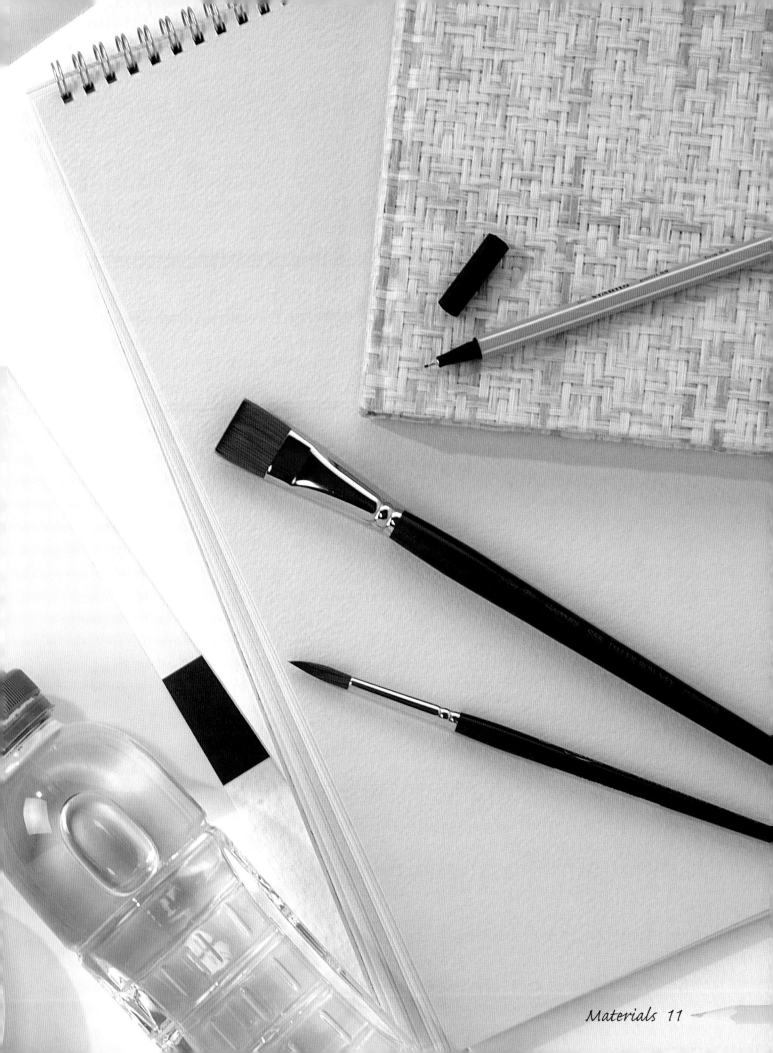

Materials 11

TECHNIQUE *Laying a foundation*

Here's a quick and clever way to make a basic wash – say for a sky. Just scribble the side of the pencil from side to side across the paper, pressing harder where you want stronger colour and easing off as you go further down the paper where you want it lighter. Don't try to fill or block everything in with the pencil.

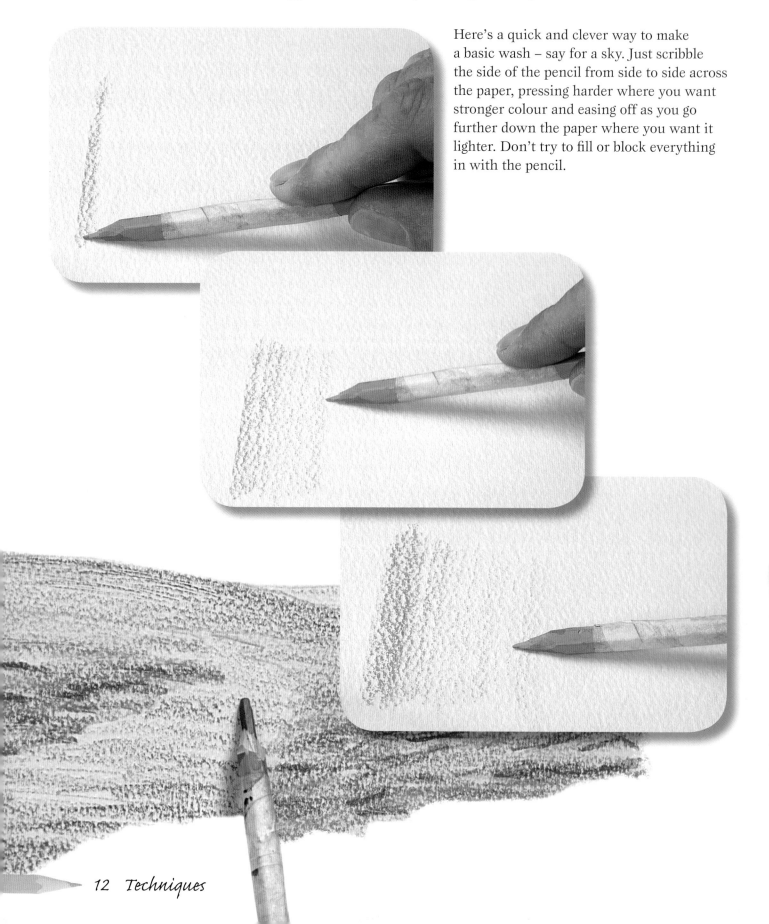

TECHNIQUE Making a wash

Here comes the magic – dip a brush into clean water and gently stroke it over the pencil marks, again going from side to side. Make sure not to overwork the brush, but rinse it and apply more clean water as you go down the paper; this will give you a weaker colour and make the wash into a graduated one.

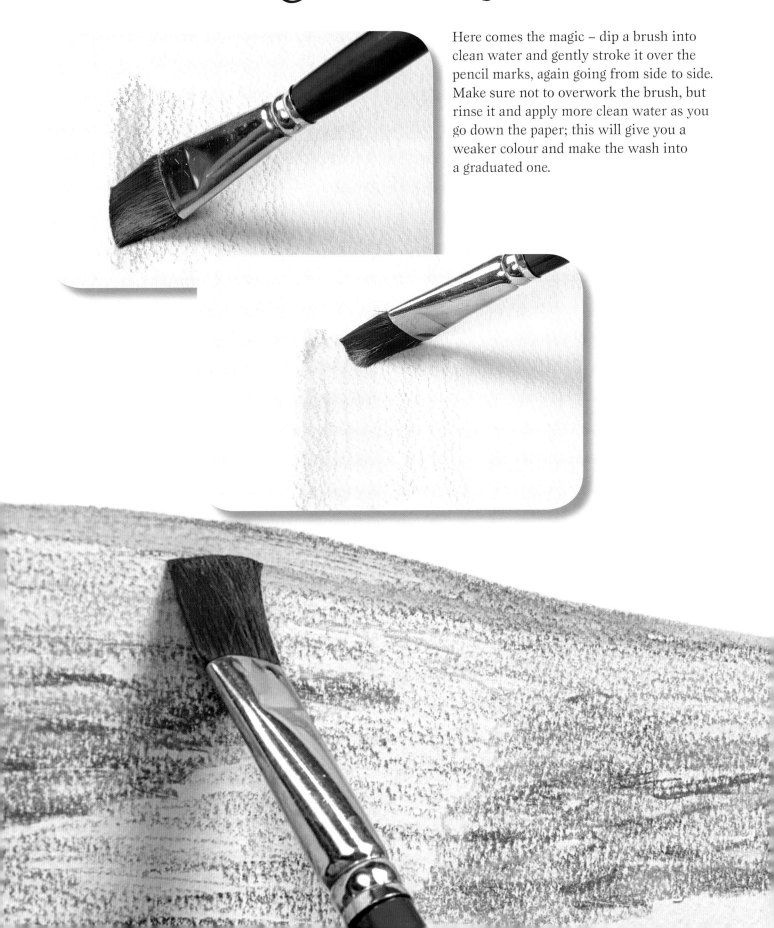

TECHNIQUE *Adding dry to wet*

While a wash is still damp, you can put a
few lines into it with a dry pencil – these
lines will spread ever so slightly on to the
damp paper, giving a nice soft effect that's
particularly good for trees in the distance,
for example. But be warned: any lines drawn
dry on to wet will be fixed when the wash
dries, and you won't be able to alter them.

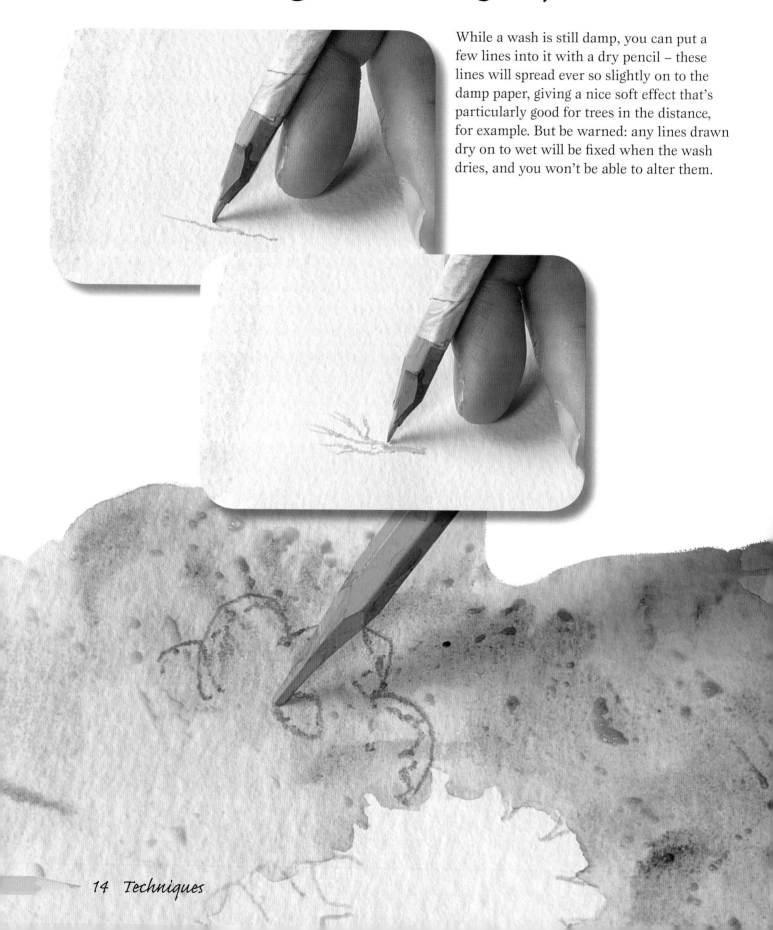

TECHNIQUE *Adding wet marks*

Another way to add colour over a wash is to take the colour off the pencil with a brush and paint it on. Use clean water for this – if you use a lot of water on the brush, the colour will be weaker, while having just a little water on the brush makes a richer, stronger colour. As on the facing page, painting lines on to a damp wash produces soft lines, while you can get harder lines by painting on to dry paper.

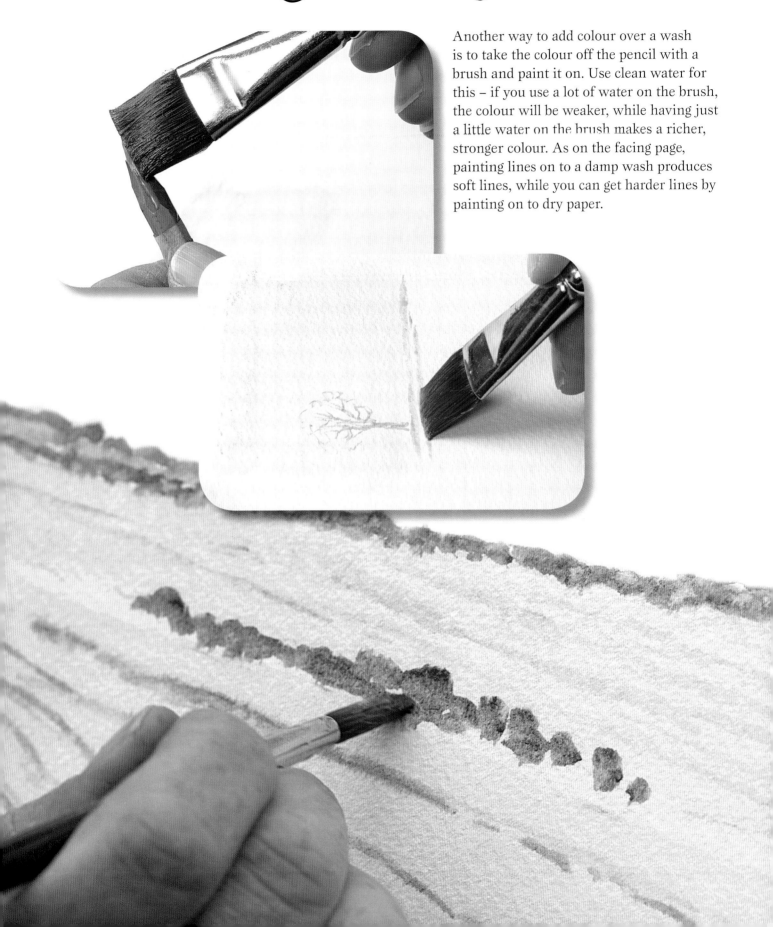

TECHNIQUE *blending on paper*

There are two ways of blending and mixing colours using watercolour pencils. The first is to scribble on an area of colour, just like a child colouring in. Then over this do the same with another colour, making sure not to block over the first colour entirely. (On Rough-textured paper, leave some of the white showing through both layers, to add texture.) Then stroke on clean water with a brush and the colours will blend to make a new colour.

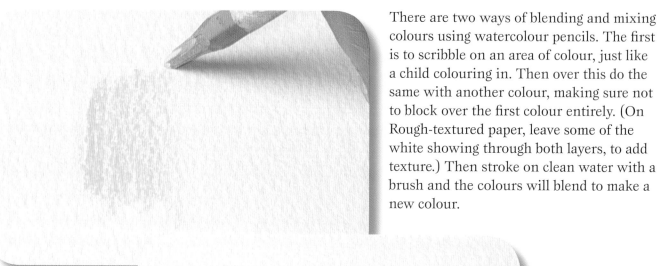

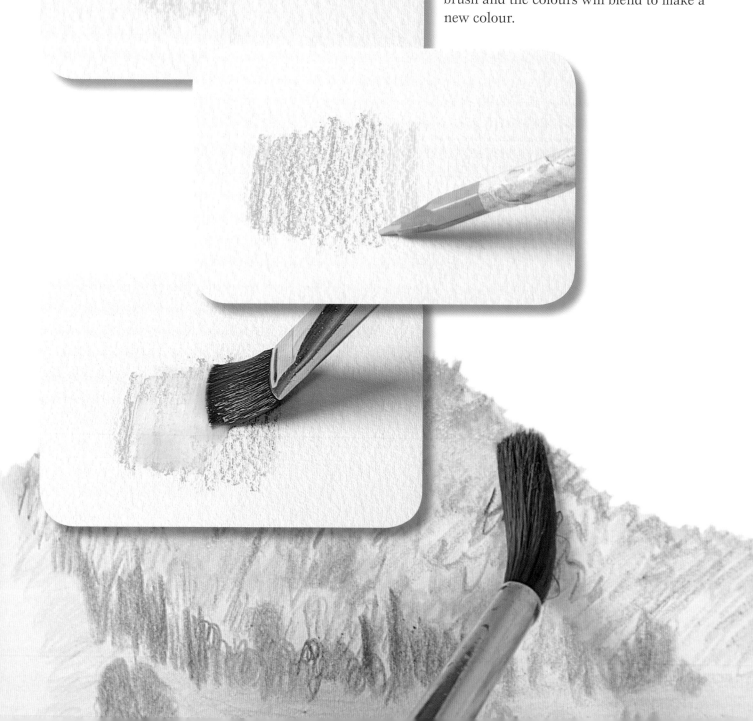

TECHNIQUE *blending on a brush*

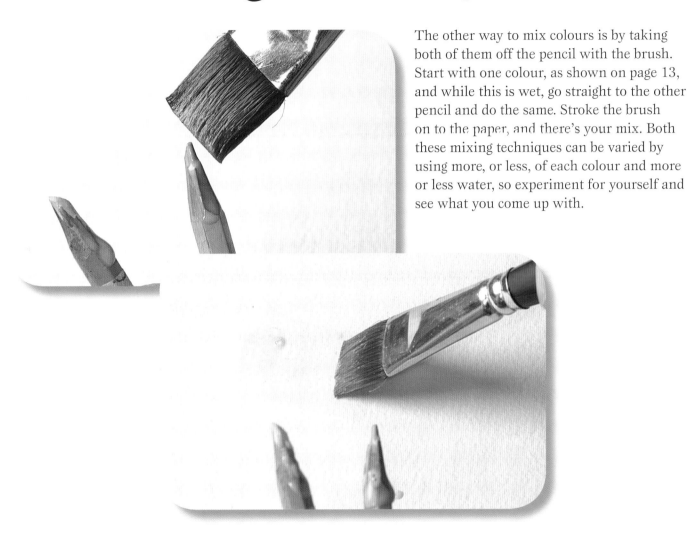

The other way to mix colours is by taking both of them off the pencil with the brush. Start with one colour, as shown on page 13, and while this is wet, go straight to the other pencil and do the same. Stroke the brush on to the paper, and there's your mix. Both these mixing techniques can be varied by using more, or less, of each colour and more or less water, so experiment for yourself and see what you come up with.

TECHNIQUE
Combining wet and dry

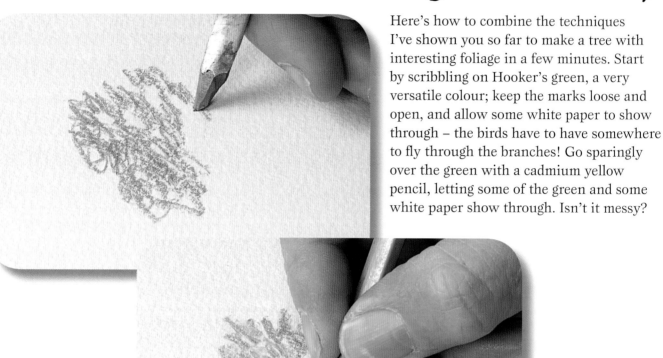

Here's how to combine the techniques I've shown you so far to make a tree with interesting foliage in a few minutes. Start by scribbling on Hooker's green, a very versatile colour; keep the marks loose and open, and allow some white paper to show through – the birds have to have somewhere to fly through the branches! Go sparingly over the green with a cadmium yellow pencil, letting some of the green and some white paper show through. Isn't it messy?

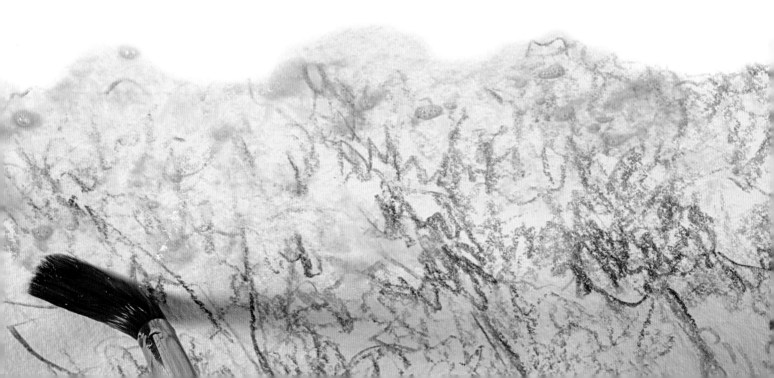

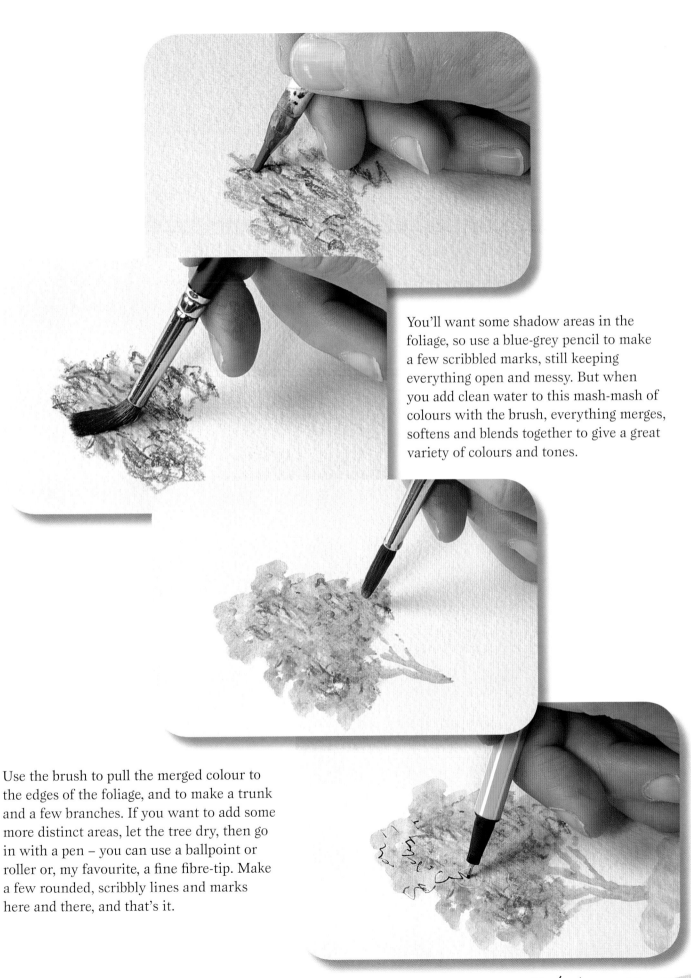

You'll want some shadow areas in the foliage, so use a blue-grey pencil to make a few scribbled marks, still keeping everything open and messy. But when you add clean water to this mash-mash of colours with the brush, everything merges, softens and blends together to give a great variety of colours and tones.

Use the brush to pull the merged colour to the edges of the foliage, and to make a trunk and a few branches. If you want to add some more distinct areas, let the tree dry, then go in with a pen – you can use a ballpoint or roller or, my favourite, a fine fibre-tip. Make a few rounded, scribbly lines and marks here and there, and that's it.

sketching tips

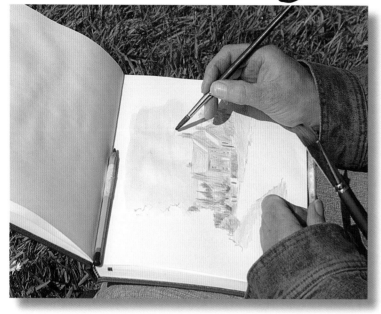

• When sketching outdoors, don't pay attention to people who wander over and look; they'll lose interest and move away.

• Always wrap up warm in anything but the hottest weather, and wear walking shoes if you're planning to go any distance. A hat and sunblock are essential in the sun.

• Folding chairs are attractive, with the bits for magazine racks, glasses of gin and tonic, and a reclining seat, but a simple shooting stick is far more portable and just as comfortable. Remember, you're not planning to sit around for hours: a quick 15–20 minutes per sketch, and off to the next location – find your scene, pick your spot, and off you go!

• Even though you're working with watercolour pencils, with their great range of rich colours, you don't have to use all of them all of the time: just one colour, stroking the side of the pencil onto the paper, and a pen produced this effective little study.

• Holidays are a great time for making sketches – and if you're near the sea, you have a ready-made source of water! People snoozing are a great subject, but you still need to try to work quickly, as this is good practice for other occasions...

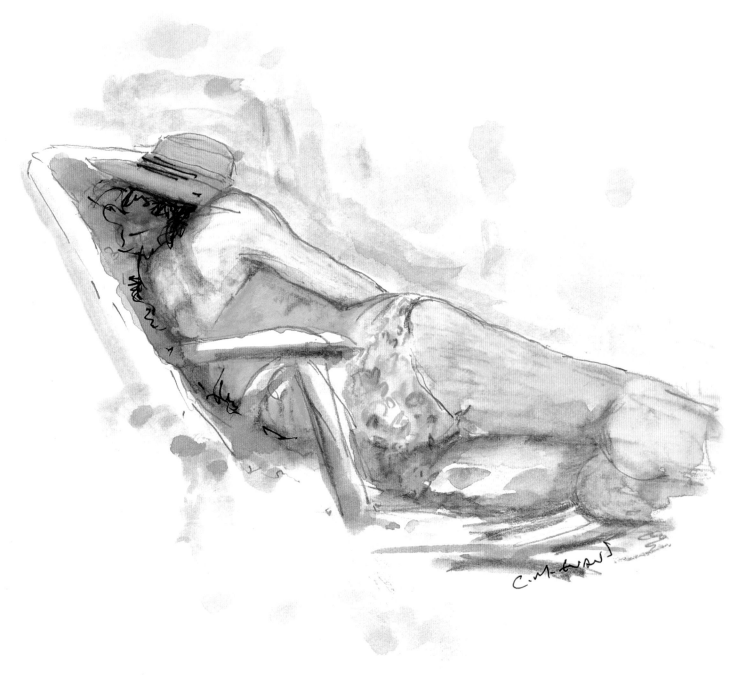

• ... such as this, when your subjects don't hold a pose for more than a few seconds. Here, just a few pencil lines reinforced with pen squiggles can do the trick.

• Take a look below: this is the full range of pencils I carry with me for a finished drawing – and I never use even half of them on any one sketch! So travel light and use what you have.

The Projects

C.M. EVANS.

Moorland

So this is the first project in the book, but don't be nervous, as I promise to be gentle with you! This is a very simple big wash painting – and if it all goes wrong, you've only used a bit of inexpensive paper (and gained a lot of experience). The thing to remember at this stage – and throughout the other projects – is that watercolour pencils are a lot of fun: imagine you're back at primary school with colouring crayons, as that's just about all this is.

I chose a light grey pencil, a lead pencil-type colour, for the initial outline drawing, and used it on Bockingford tinted water-colour paper.

1

As I said, this is a very simple scene, so I have drawn the basic outline shapes of two distant hills, a bit of moorland in the middle, an area for some foreground grasses and a path. Watch my fingers in these steps: here I'm checking the path in the foreground...

2

... and here at its furthest point. The only thing you have to get right in this picture is to make the path wider in the foreground than in the middle distance – this is simple recession, which leads the eye into the picture from the front to the back.

3

There aren't many colours in this picture, and I start by using blue-grey to shade in the distant hills, just colouring them in. As with any other pencil, if you want a strong colour, press the pencil hard, and go more lightly for a weaker colour.

4

Having made the left-hand hill darker than the right-hand one, I move on to the green moorland on either side of the path using Hooker's green. Again, I just scribble the pencil on the paper, pressing lightly in the distant areas and then harder as I come to the front of the view.

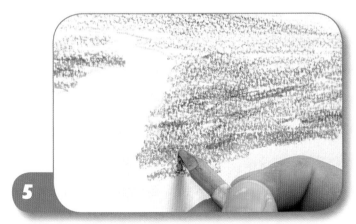

5

Grass is never just one colour, so to add interest and variety I put a few blotches of burnt sienna into the deeper green foreground area. What a mess it looks, but it will all come right in the end!

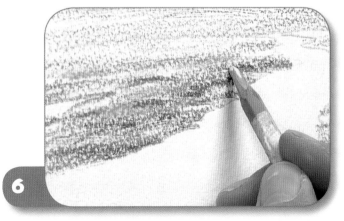

6

And now I switch to a cadmium yellow pencil and do the same with this, sometimes going over the brown. These are just patches of colour, and I'm not trying to cover all the green. I'm sure every mother has things that look better than this stuck to the fridge door.

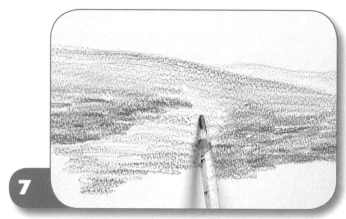

7

That's the pencil part of the colouring nearly done; returning to the blue-grey I used for the hills, I stroke the pencil very lightly over the path, again pressing harder in the foreground than in the distance.

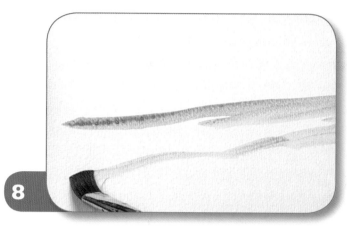

8

Now comes the reason for using watercolour paper: I wet a ¾ in flat wash brush with clean water, then stroke it over the pigment of the blue-grey pencil to take up the colour (see close-up below). Working quickly, I brush this on to the sky area.

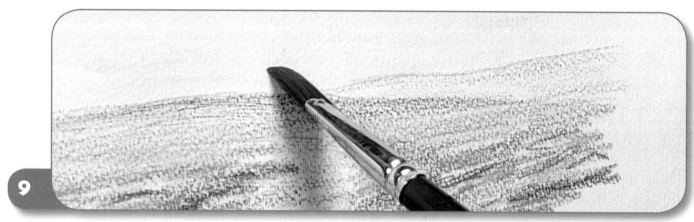

9

While these first marks are still wet, I wash out the brush, load it with clean water, and stroke over the first marks, to dilute and soften them and bring them over the whole sky, making sure to leave a few bits of paper showing... and

that's the sky done! Simple, isn't it? It's amazing how scared many people are of starting watercolour painting – well, this is like watercolour painting on a stick, and it's nothing to be nervous of at all.

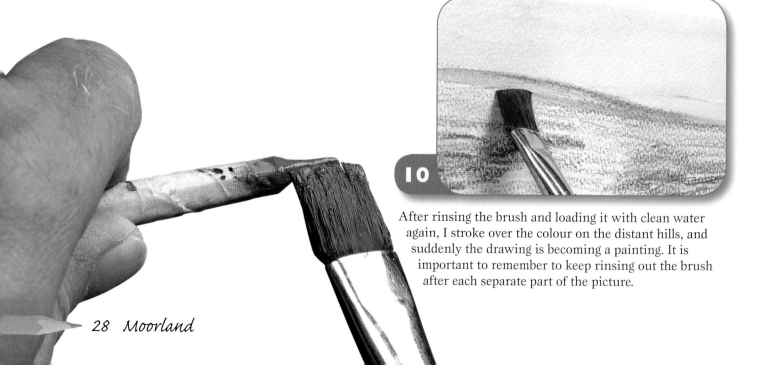

10

After rinsing the brush and loading it with clean water again, I stroke over the colour on the distant hills, and suddenly the drawing is becoming a painting. It is important to remember to keep rinsing out the brush after each separate part of the picture.

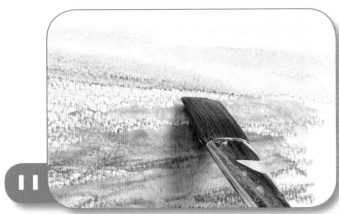

11

With a clean brush I move into the middle ground, both tapping and stroking the coloured surface; I leave some pencil marks showing through here and there to give a variety of textures and effects. As I work on these areas I can see all the colours on top of the green merging together.

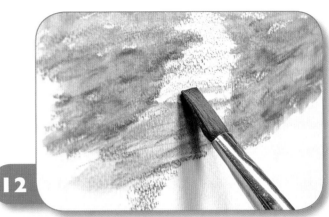

12

I give the brush a thorough rinse, and then load it with clean water again. As I stroke the water into the path I bring the colour down and use the varying density of the pencil strokes to add texture to the surface.

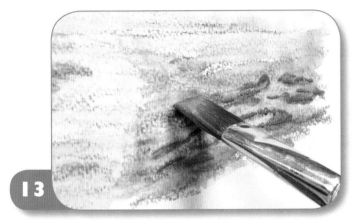

13

To show the contours of the ground as it slopes towards the path, I take pigment off the blue-grey pencil, but this time using less water than before, and stroke it on...

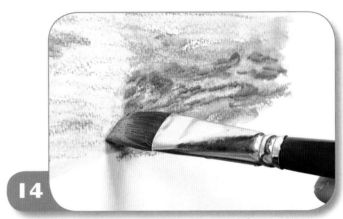

14

... tapping with the edge of the tip of the brush here and there as I near the path. While the paint is still wet, I quickly wash out the brush and load it with clean water.

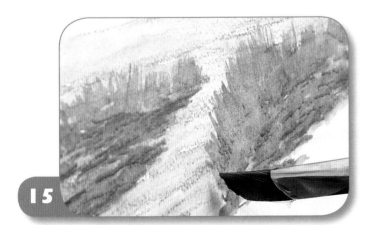

15

Using the tip of the brush, I flick the wet paint upwards to represent some long grasses in the foreground. Now you can see the lighter grass showing through the darker stuff – simple but effective.

16

And there we are – a painting with watercolour pencils! Not too difficult, was it? To finish off, I sign the picture with a fine fibre-tip pen, and add a tick and a stick in the sky – and there's a bird of prey hovering in the air.

Monochrome

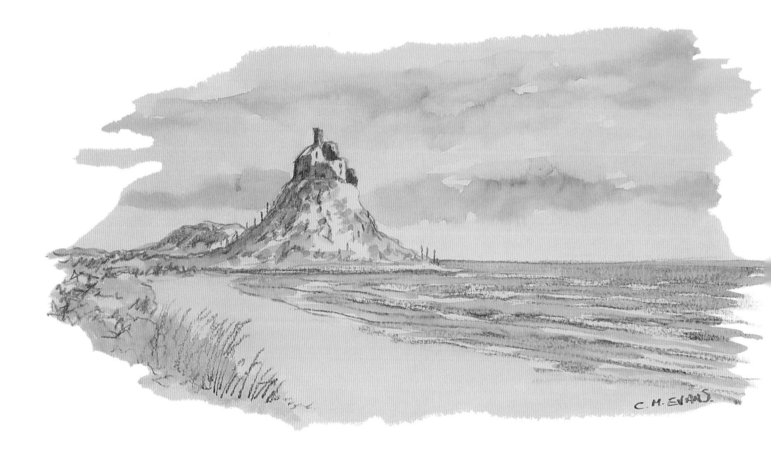

C. M. EVANS.

Even though the last project used only a few colours, these can still seem daunting to the novice artist, so here's a view of Holy Island or Lindisfarne, off the Northumberland coast, done in one colour to show how easy it is to get a pleasing effect. This is a tiny castle (I call it semi-detached), but when J.M.W. Turner painted it from out at sea, he made it seem immense, with waves crashing against Everest-sized rocks!

For the drawing I used a burnt umber pencil on cream-tinted Bockingford watercolour paper.

1

Even in a simple outline drawing like this, it's important to graduate the pressure on the pencil so I can have texture and variety in the later stages. 'Graduate' – if I'm not careful, I'll be getting technical!

2

As I add the sea, note how much paper I leave showing through in order to suggest movement and ripples. This Bockingford paper has a lovely rough surface, so if I don't press too hard, I leave little bobbly bits of pigment on it.

3

I also leave parts of the paper showing through in the darkest parts of the castle, on which I use quite a lot of pressure. On the hillside, I look for contours and an impression of movement using different lengths of pencil strokes.

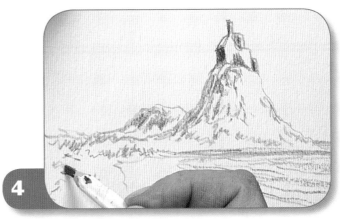

4

As in the previous project, I treat the beach like a path, making sure it is wider in the foreground than in the distance – this is recession, leading the eye into the picture. And that's the drawing done: basic shapes, colouring in and everything.

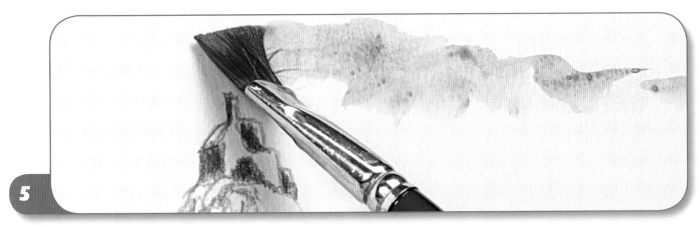

5

Now it's time to start adding water. Using burnt umber on cream-tinted paper to paint a sky might sound somewhat weird, but it's amazing what seems natural and right in a monochrome picture. So I use a ¾in flat wash brush dipped in clean water to take the colour off the pencil and stroke it on to the paper in zigzag lines.

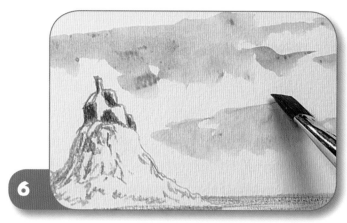

6

Even in one colour, it's possible to get a great variety of effects: I use varying pressure on the brush, add and reduce the amounts of water and pigment, and leave areas of the paper untouched to give the impression of sky and clouds.

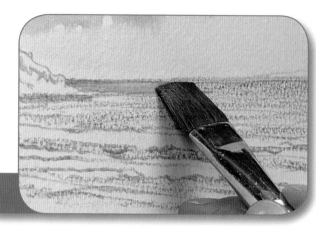

7

I use the same brush to go into the sea. Again, I'm not attempting to cover the whole surface with water, but am looking for movement and variations. In the distance I start by stroking on long lines...

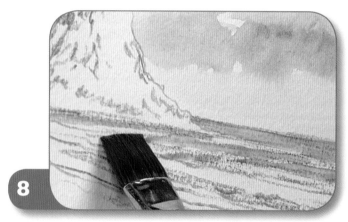

8

... and as I come into the middle distance I break the lines up to show the motion of the waves. I make sure to leave some areas of paper untouched and to show some of the pencil lines...

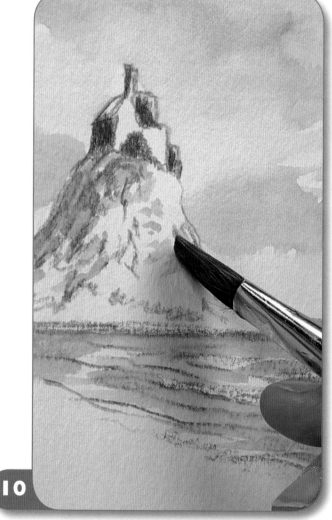

10

I take some nice darkish colour off the pencil and add this to the left-hand hillside, then pick up the paint from these places and tap it into others. This creates texture, undulations and bumpiness, particularly when allied to areas of untouched paper.

9

... and by the time I reach the shoreline I'm tapping on the brush. When this wash has partly dried I go over some parts of the sea with clean water, to soften the marks and bring a sense of unity to the sea.

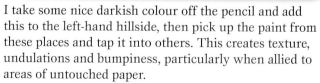

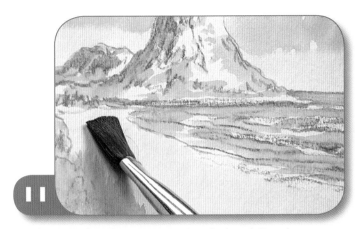

11

To show the beach I just put a few flicks of dirty burnt umber-tinted water on with the brush, then smooth these along the sand.

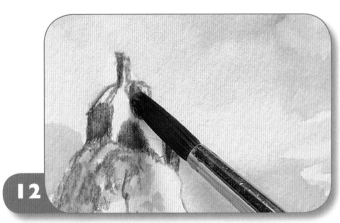

12

The darkest parts of the castle are the most dramatic. I use a No. 8 round brush with a little water to wet the drawn sides, again leaving some paper to show through.

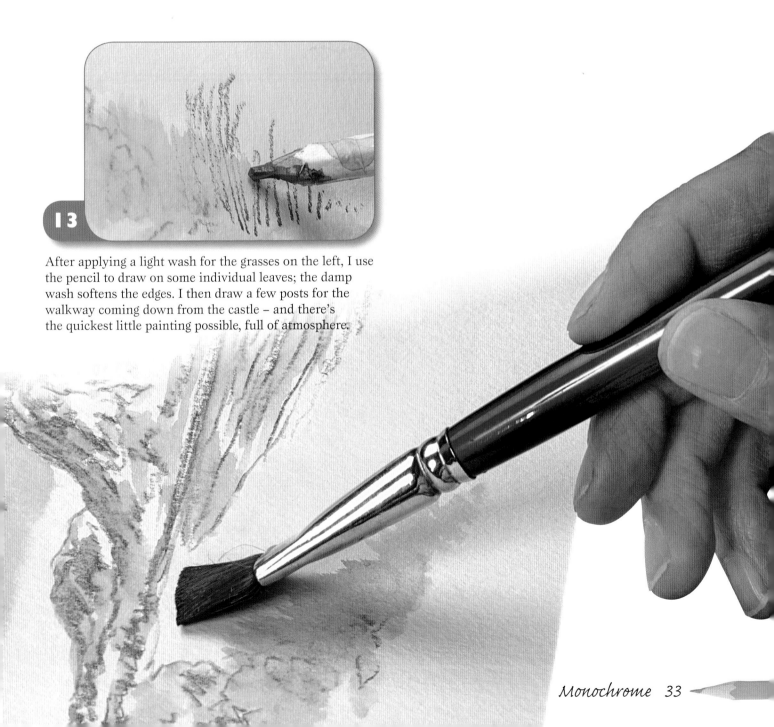

13

After applying a light wash for the grasses on the left, I use the pencil to draw on some individual leaves; the damp wash softens the edges. I then draw a few posts for the walkway coming down from the castle – and there's the quickest little painting possible, full of atmosphere.

sketchbook: Woodland and Fields

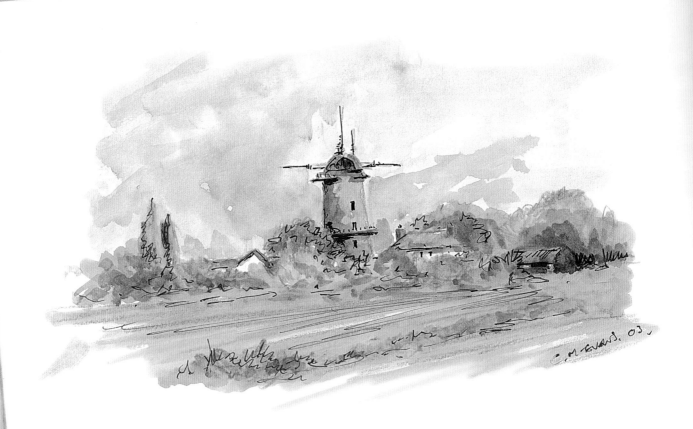

A large focal point, such as a windmill, is an obvious subject for a sketch...

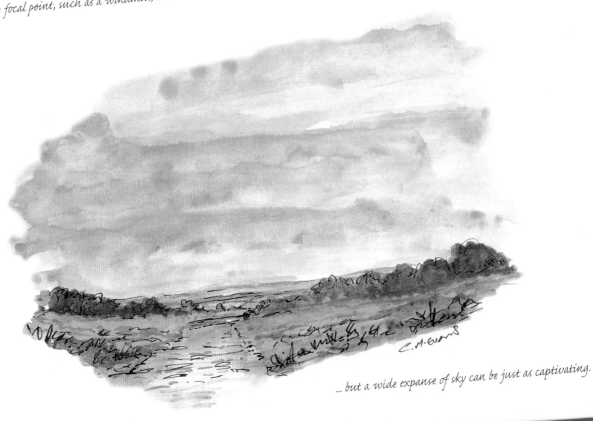

...but a wide expanse of sky can be just as captivating.

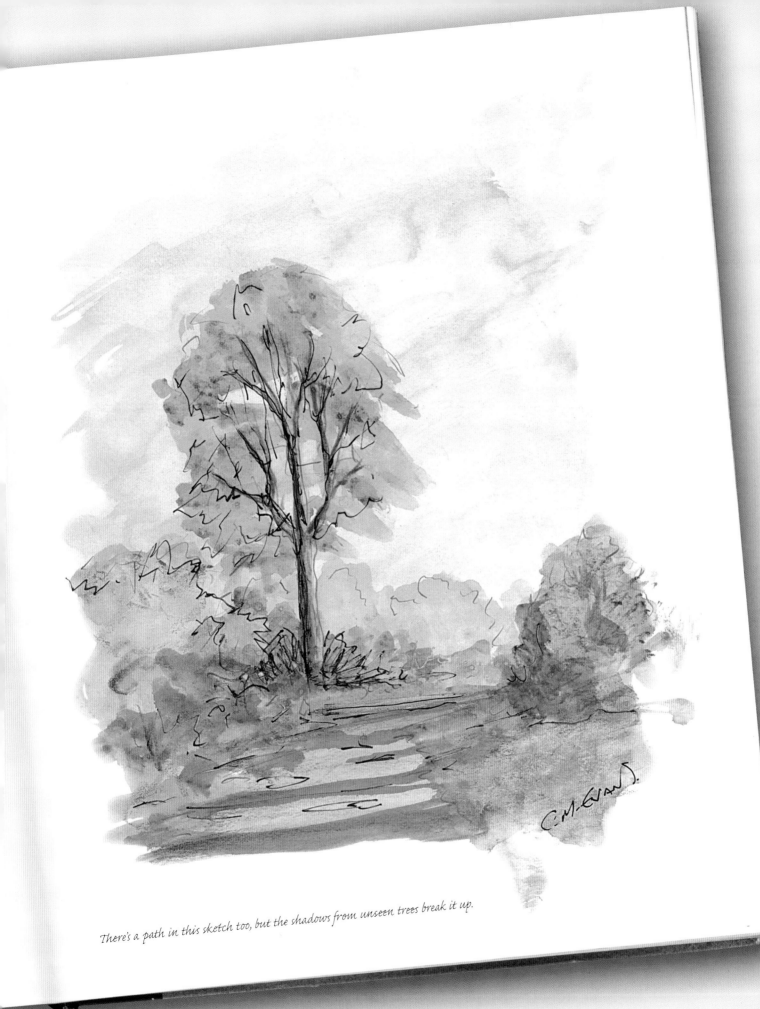

C.M.Evans.

There's a path in this sketch too, but the shadows from unseen trees break it up.

Woodland and Fields

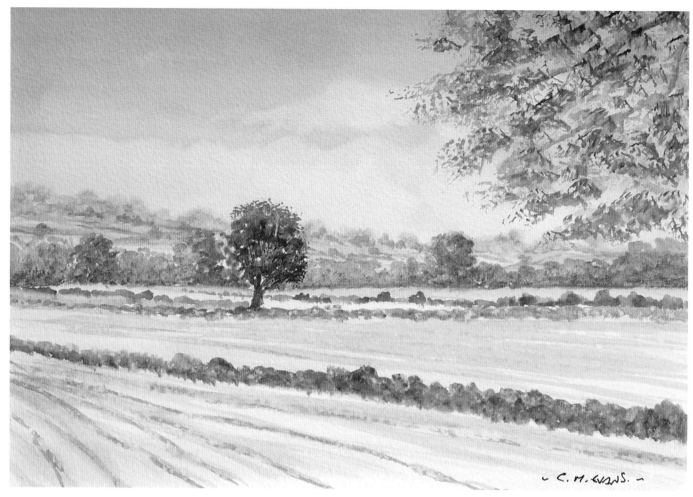

This particular landscape is right outside my back door – you don't always have to travel far to draw or paint. I've made a feature of the single tree in the field, and along the way I removed a telegraph pole that interfered with the composition; there's no harm in moving, adding or removing things, as long as the end result is good.

I used cool grey pencil for the initial drawing on watercolour paper. The trees were just rough shapes, without any details, and I didn't draw the poplar on the right at all.

To start, I take manganese blue off the pencil with a ¾ in flat wash brush, and then work it quickly across the sky area. While this is wet I go into it with a slightly darker version. (The bubbles you can see will disappear as the washes dry.)

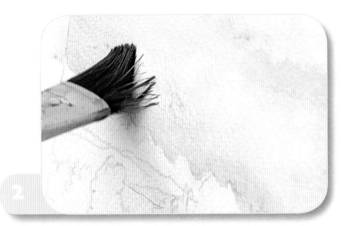

I rinse the brush in clean water and squeeze it nearly dry, then suck some of the damp pigment off the paper to form clouds. Hey presto! Sky with a minimum of detail.

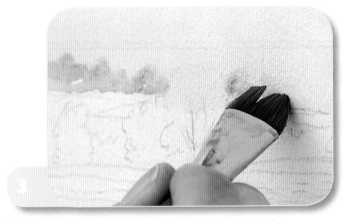

Working quickly while the sky is still damp, I take some blue-grey off the pencil and use the edge of the brush to put in the furthest trees. As it blends into the sky washes, this gives a soft, hazy, distant effect.

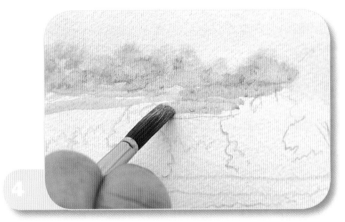

While this latest wash is damp, I switch to a No. 8 round brush to tap on some Hooker's green and viridian for the slightly closer trees; I keep these washes weak. After drawing down some strokes of green, I add yellow ochre to give a patchwork effect for the far fields.

I add some blue-grey blobs for bushes, just tapping on the colour with the brush, and stroke on olive green, again taking the colour off the pencil, in the middle distance in front of the field. Now I've created a view with true distant softness, all with a few blibs and blobs.

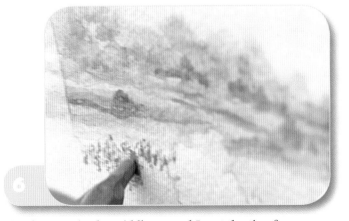

For the trees in the middle ground I wet the tip of a yellow ochre pencil with clean water and draw on some short lines; these more permanent marks have a slightly stronger colour than those in the distance, adding to the impression of recession in the picture.

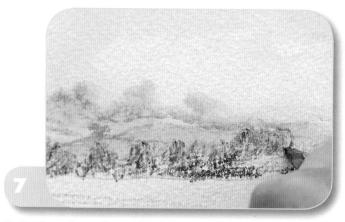

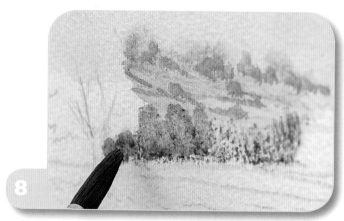

Going into the yellow ochre, I scribble on viridian and then blue-grey for the base of the trees. The secret here is not to go in too hard; if this section is too dark, what can I do for the foreground? Now take a look at the result – what a mess it seems to be!

But now it is time to make sense of the mess: I stroke clean water on to the pencil marks with the No. 8 round brush, and suddenly there is the green foliage of a distant woodland. I leave a few touches of the underwash showing, big enough for a squirrel to appear through the foliage.

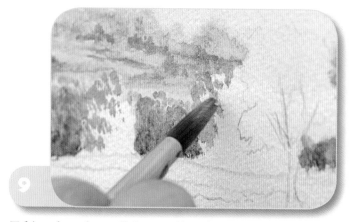

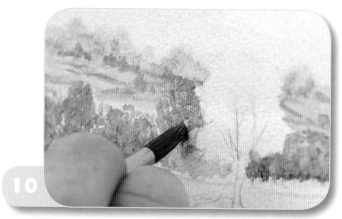

Taking the colour off the pencil with a clean brush, I stipple small marks of yellow ochre on to the more pronounced mid-distance trees; I use a little water and 'split' the brush hairs on the paper to give a leafy effect.

I follow this with sap green, again 'splitting' the brush; to show the direction of light, I work on the right, leaving the left-hand side of the tree more ochre.

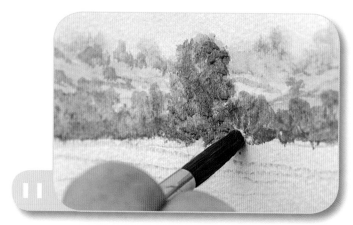

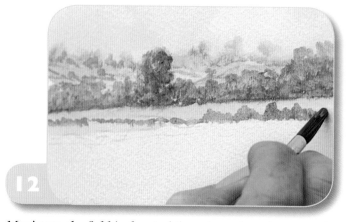

The next colour for the trees is a stronger, darker Hooker's green, and I then add warm permanent magenta to give the shadow colour under the more prominent trees.

Moving to the field in front of these trees, I stroke on a pale wash of sap green, then put in a touch of cadmium yellow for the next bright field of rape. I separate these with a hedge, a mix of viridian and permanent magenta, made on the brush, just stippling on these bobbly bits.

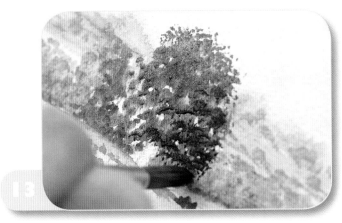

For the main tree I put on a bright wash of cadmium yellow to make it stand out, then tap on a stronger mix of viridian and magenta, 'splitting' the hairs of the brush for the effect of leaves. I apply Mars black to the bottom of the foliage, and drag it down the trunk and base.

I begin the foreground field of oilseed rape with a strong wash of cadmium yellow, painting long lines from side to side and leaving the front hedgerow area untouched.

Across this wash I drop in diagonal lines of viridian for tractor tracks and lines of weeds; this gives a flow to the field. Returning to the viridian and magenta mix, I put in the middle hedgerows, which get slightly darker towards the right side of the picture.

After going over the foreground field with an even stronger cadmium yellow wash, I use the viridian and magenta mix for the large hedgerow. This time I drop in a touch of blue-grey at the base in a scrappy line that gives the impression of crops growing in it.

The last stage is to put in the poplar tree on the right side. I begin by stippling in lines of yellow ochre, followed by Mars black on the underside while these are damp. I make sure the lines had a broken, dotty feel.

'Splitting' the flat wash brush, I stipple on a dryish wash of yellow ochre for the foliage. I then add Hooker's green, twizzling the brush to show the twigs appearing through the foliage. I finish by doing the same with a mix of blue-grey and Mars black – and there we are!

Flowers

Many people think flower painting must be really difficult, but I'm going to do a bunch of flowers that is extremely colourful but not in the least complex. There are lots of flowers here, but I have initially drawn only three big daisies, in blue-grey pencil on Langton Rough watercolour paper. The finished picture will be cheerful and bright.

Using a ¾in flat wash brush, I start by wetting the paper with clean water, cutting carefully into the initial drawing of the flower outlines.

I cover the whole of the rest of the paper, putting on as much water as the paper can stand. Knowing how much you can put on and still keep control is a matter of trial and error – and if it doesn't work, start again.

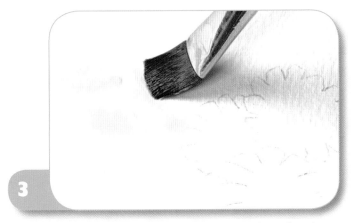

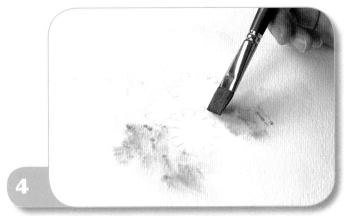

Taking the paint off the pencil with the brush with quite a bit of water, I drop a good, strong wash of cadmium yellow on to the watery parts of the paper...

... then quickly clean the brush and charge it with cadmium red, applying this to the watery paper in the same way...

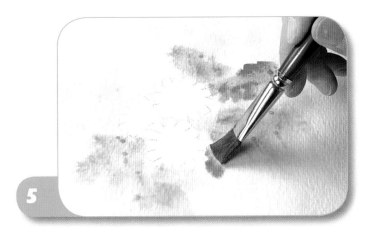

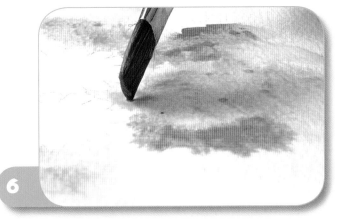

... and the moment this is done, I clean the brush again and take a lovely permanent magenta off the pencil and drop that in as well.

I use the side of the brush tip to cut into the outline of the white flowers; this also has the effect of bringing the colours together, which then blend and merge softly on the wet paper.

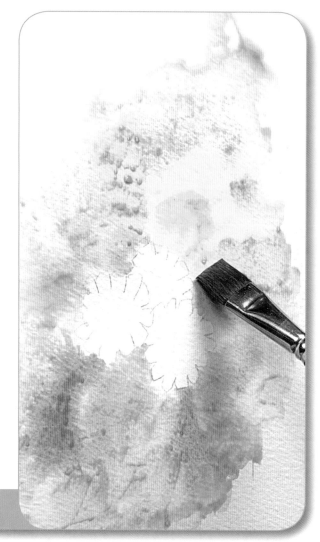

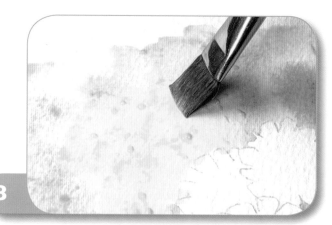

8

With most of the picture area covered, I go over the areas of the nearest coloured flowers with slightly stronger washes. Any bubbles in the wet paint will disappear as the painting dries.

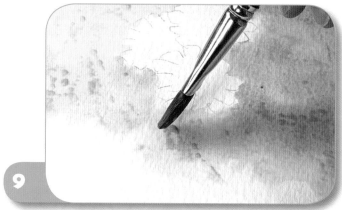

9

7

Still working quickly, I move out from the centre, dropping in the colours to suggest the effect of a large bunch. Although the water is doing most of the work, I am still careful to drop the paint in where it will take the rough shape of a flower head.

To start the greenery and foliage, I put in a little sap green via the brush, letting the colours spread and blend a little to give a really bright area, splodged on all over the place. This really is looking a lovely mess!

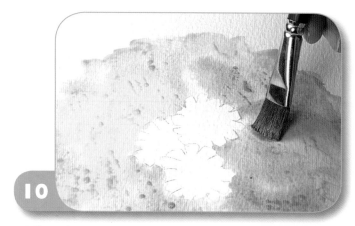

10

11

I follow this with a darker green, Hooker's green, again off the brush, tapping and dabbing this onto the damp paper to give some variety in the greens.

Amid the splodges of green, I use the tip of the brush to pull the colour up to make a few stems poking out of the general mêlée of colours and shapes.

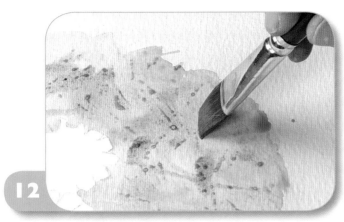

12

As the greens begin to dry a little, I make a stronger wash by mixing Hooker's green and blue-grey on the brush; using less water than previously, I stipple this to strengthen some of the green areas...

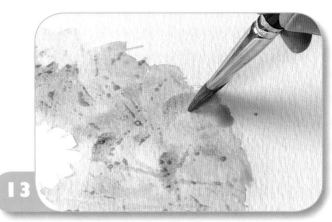

13

... and even form a few leaves by turning the sharp edge of the brush as I apply some more pressure. Amazing – a leaf shape in a second!

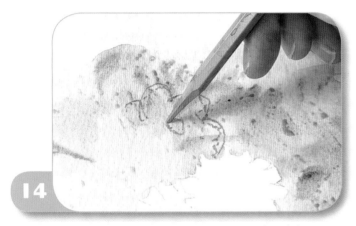

14

I then switch to a dry cadmium orange pencil and draw some soft flower shapes into the still-damp washes; these don't have to be detailed at all. I also tap the pencil on here and there...

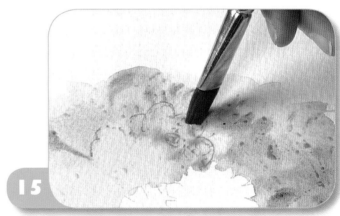

15

... and then use a clean wet brush to further soften the pencil lines while leaving them visible.

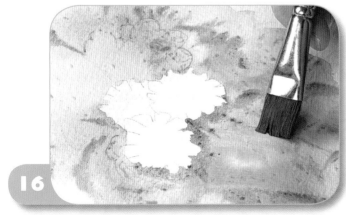

16

Using blue-grey taken from the pencil, I paint carefully around the white flower outlines. With the same colour I begin to shape some of the splodges into flower shapes. At this stage, everything is getting stronger as the darks go on.

TIP
THE PAPER SHOULD STAY SOPPING WET FOR A GREAT DEAL OF THIS PICTURE, SO BE BOLD WHEN PUTTING ON THE WATER.

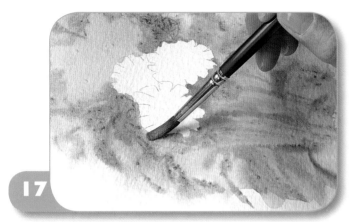

17

To strengthen and further form the flowers around the daisies, I make the washes of cadmium orange and cadmium yellow stronger, using a No. 8 round brush. The paper is still wet, so these washes also spread and soften.

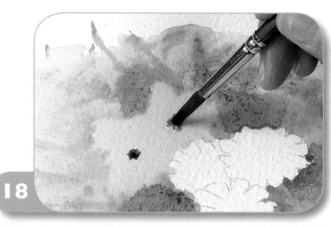

18

Taking the colour off the pencil, I drop a couple of blobs of Mars black into the centre of the yellow flowers. I then use a stronger version to do the same in the reds – the flower colour is stronger, so the effect is muted.

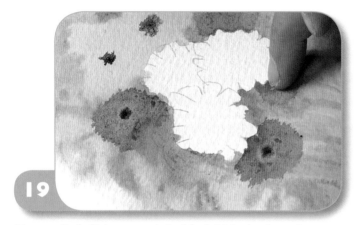

19

To get a little light around the black blobs in the red flowers, I take the colour off the paper by dabbing my finger onto the wet paint.

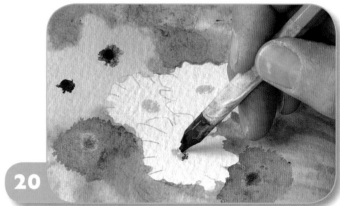

20

I draw the centres of the daisies with a dry cadmium yellow pencil, and follow this with a little dry Mars black at the bottom of each bit of yellow.

TIP
ONCE YOU START WORKING ON THE WHITE FLOWERS, BE PREPARED TO GO BACK AND STRENGTHEN SOME OF THE OTHER COLOURS.

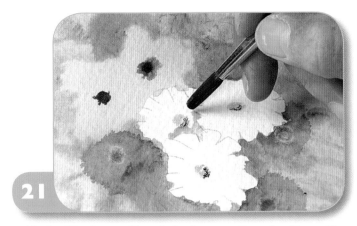

21

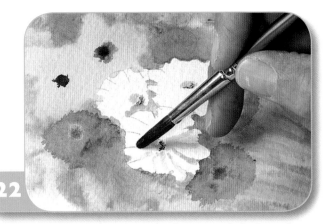

22

With the No. 8 round brush I take some Prussian blue off the pencil and put in the blue shadow tints on the white daisies, starting at the bottom of the top flower...

... and continuing lighter into the foreground shadowed areas of the other daisies. I go back to the top daisy with a much lighter wash, and then use the same colour less distinctly in the background flowers.

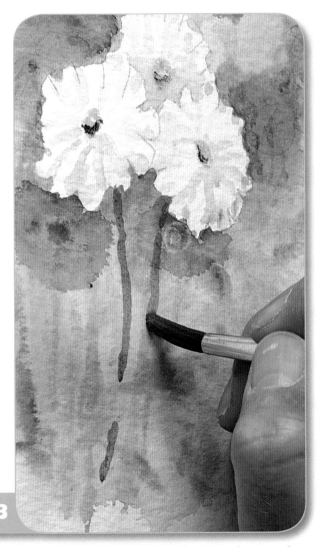

23

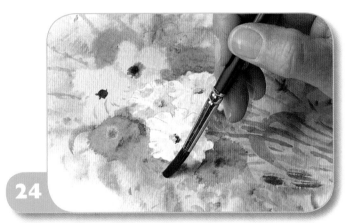

24

I use a tiny bit of blue-grey and a lot of water to blend together some of the background colours; most of the paper is still damp, if not wet, so the colours blend softly.

25

Taking the colours off the pencils and mixing them on the brush with a little water, I dab and stroke a strong wash of Hooker's green and blue-grey to make the stems and leaves of the daisies. I use a lighter version of this mix among the background flowers.

The final stage is to use a fine fibre-tip pen to make a few lines, marks and squiggles to pull parts of the picture together. I am careful not to let the penwork take over, as I want to make just a few distinct areas, not many. And there's an attractive, simple flower picture.

Autumn Leaves

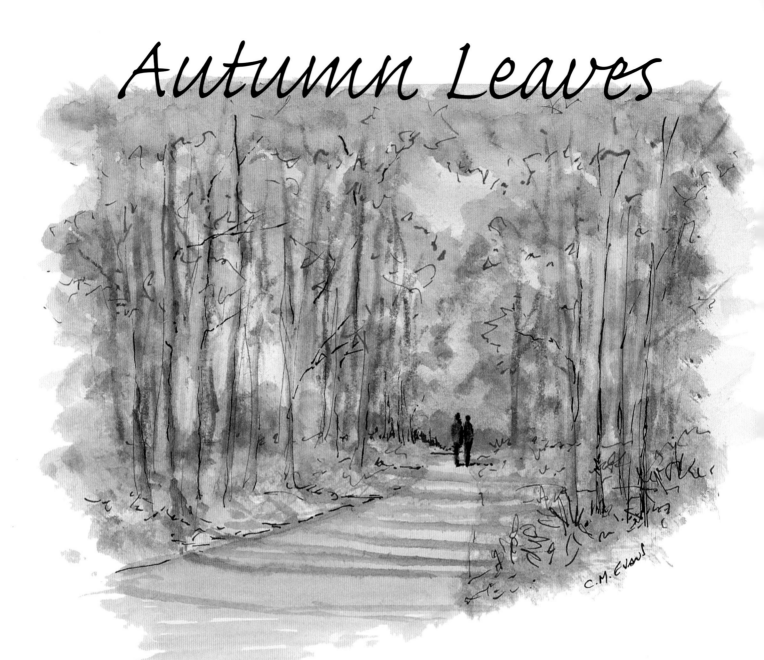

C.M.Evans

I couldn't get to New England for this scene, unfortunately, so I worked from a photograph as reference. When drawing and painting from a photo, first of all take a good long look and figure out what your techniques and approach are going to be, and how you intend to handle putting on the colours – as you'll have gathered by now, there are lots of different ways of using watercolour pencils! Whichever you choose, the pencils have the strong, vibrant colours ideal for autumn woods.

I didn't do any preliminary drawing for this project. The paper was high-quality catridge paper from my sketchbook, which can take a lot of working.

1

I start by taking Prussian blue off the pencil with a No. 8 brush and working the colour liberally across the picture. This is not so much a classic landscape 'Big Sky'; it's more about getting the right light and colour for a backdrop.

2

While this wash is wet, I drop in the background trees using first Hooker's green and then go in with a stronger wash of Prussian blue. The colours spread slightly, bleeding together to give a soft, hazy effect.

3

Now what about the trees in the foreground? Simple – with a slightly damp ¾in flat wash brush I suck the wet pigment out of the paper to give white trunk shapes. This technique works best on damp paper, and I am careful not to leach out too many foreground tree shapes.

4

I switch to a blue-grey pencil to draw a few stick lines for distant trees, varying the pressure of the lines. Because there is a lot of foliage about, once more I draw only a few; and because the washes are damp, the lines have lovely soft edges.

5

To get stronger effects as I come forwards in the picture, I use a raw umber pencil, which makes an effective contrast with the blue-grey. Again, less is more, so I take care to err on the side of caution.

6

Using a light wash of raw umber, I start to shape the path, as always making it wider in the foreground than in the distance. I then use yellow ochre and cadmium yellow pencils to draw some scribbly bits beneath the trees – this sort of drawing is great fun!

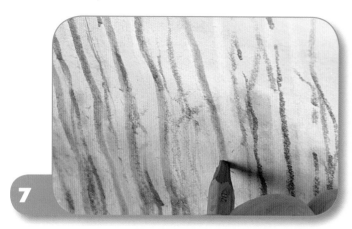

7

For the foreground tree trunks I use the blue-grey pencil, leaving a strip of white on the left of each one to show where the light is coming from. I invent a few twigs and branches – it would be impossible to show every one – and add raw umber to the shadow sides.

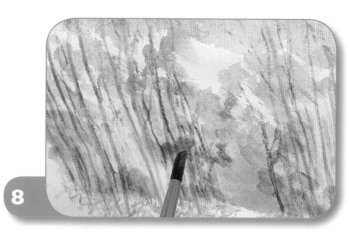

8

I take yellow ochre off the brush with the No. 8 brush and then tap and dab on the top leaves; I don't count them, I just paint them! To help build up an autumnal colour scheme, I use burnt sienna to suggest the russets and golds overlaid on top of each other.

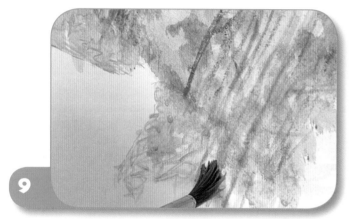

9

Using the round brush, I stroke clean water onto the tree trunks, again making sure to leave the white side facing towards the light. After rinsing the brush, I use raw sienna and a lot of water to tap and merge the browns and yellows on the woodland floor, and hey presto! All the squiggles merge and turn into a canopy of leaves.

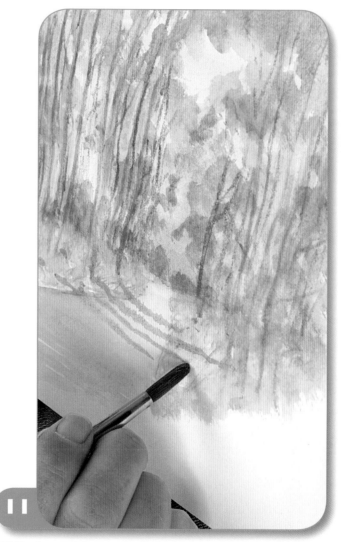

11

While the path is wet, I take some tree shadows across it to give it shape and dimension, using a mix of blue-grey and permanent magenta; for the shadows that lie further away up the path, I weaken the mix.

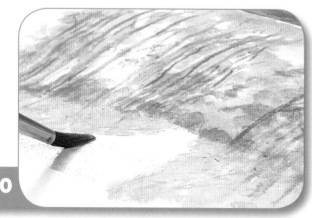

10

To fill in the path I stroke a little raw umber off the pencil and put it on with light strokes of the brush. This is a quick stage, as there isn't any point in fiddling about.

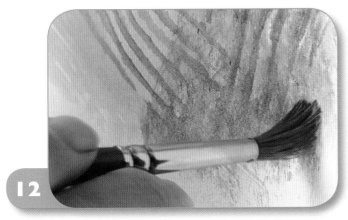

12

I stipple the shadow colour on to the woodland floor using almost no water and 'splitting' the brush hairs. After edging the path gently, I put some of the shadow mix into the foliage in the tops of the trees – again, only a little.

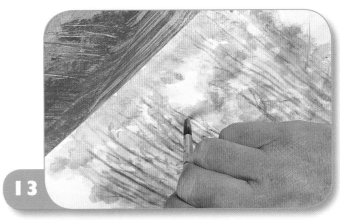

13

Across the top of the trees I dab on cadmium yellow from the brush to give a bit of extra colour without going mad. See the difference? This brightens everything up immediately, and I leave it to dry for a few seconds.

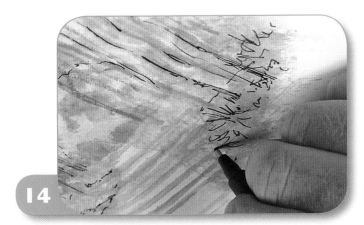

14

To reinforce some of the tree and twig lines I switch to a fine fibre-tip pen; this is just a backup tool, however, and I therefore use it very sparingly and then move to the leaves on the ground with a few scribbled, random lines at the bases of the trees. A few lines here and there among the foliage on the trees help, but again, only a very few.

15

At this point it occurs to me that a touch of life might benefit this lovely little view – and whose picture is it, anyway? Adding a couple of distant walkers isn't difficult: one blob of cadmium red and one of Mars black from the pencils is all it took.

16

I tap on water with the No. 8 brush, remembering that the people will also cast shadows; I bring the colours across from the drawn marks, then reinforce the figures and heads a little with the pencil. And there's New England in the Fall.

Reflections in still water make great sketchbook subjects.

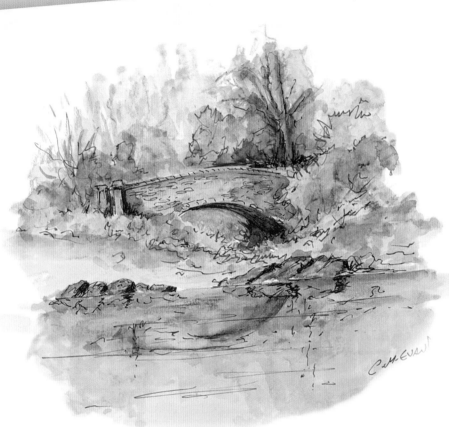

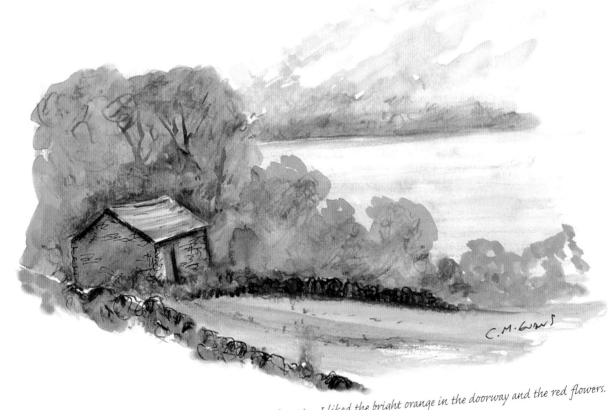

Your sketchbook is a good place for practice and experiment – I liked the bright orange in the doorway and the red flowers.

The sun on the sail made the sky behind very dramatic.

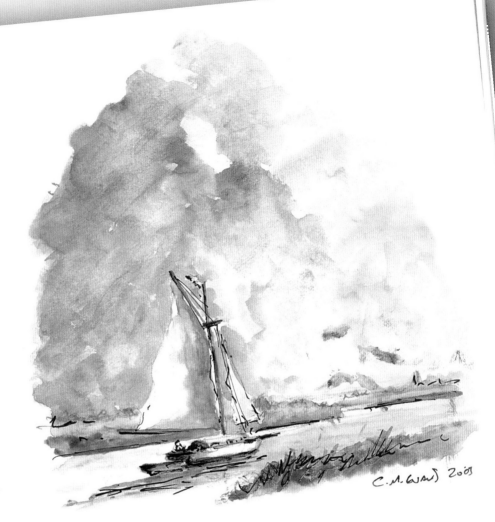

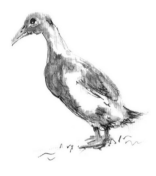

I had to work quickly to get this duck on paper.

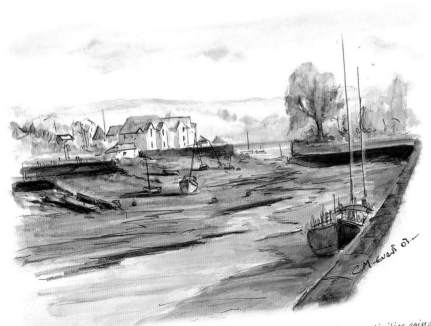

Birds and boats — now there's a winning combination!

Harbours are fascinating; you can sit all day and sketch the different activities going on.

Lake

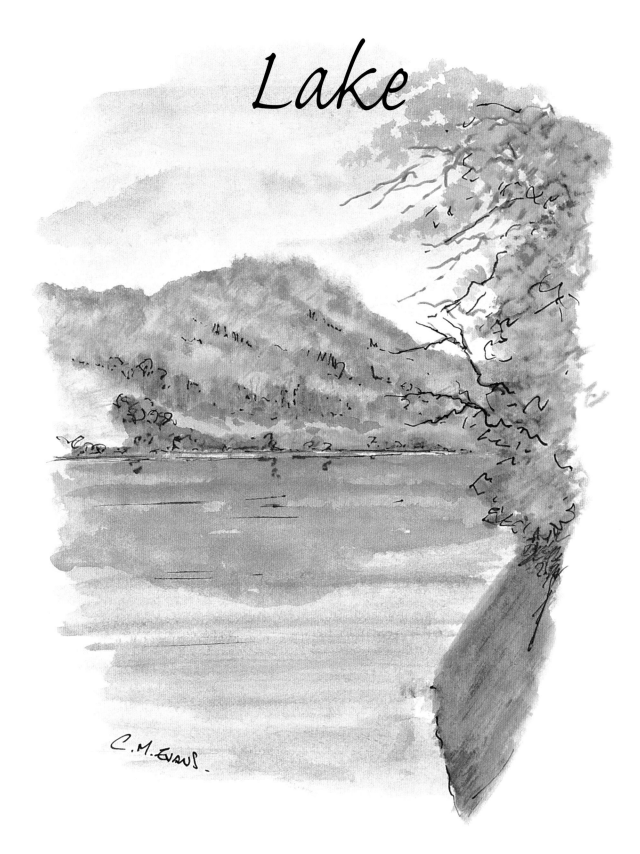

C.M.Evans.

Quite an unusual one, this – although it's a landscape, I decided to do it in a portrait format. Why? Because it's a lake scene, and I want to see a lot of lake! I made an outline drawing in gunmetal grey, put a bit of land in the foreground to frame the lake, and added some bushy bits above it.

1

I start by filling in part of the hillside with Hooker's green, as above; I don't want too much of a block of colour, so don't press too hard with the pencil. Detail isn't needed at this stage, so I don't put in tree shapes.

2

To add variety to the hillside I follow the green with more strokes in cadmium yellow, then orange and then yellow ochre. It's beginning to look rather messy...

3

... and looks more so when I put in a few touches of olive green to give some variation to the darker Hooker's green. But even with all these colours I make sure not to shade in everywhere, as this bit is in the distance.

4

To give more of the cool feeling of distance, I drop in some Prussian blue towards the hill top and then some blue-grey behind the more distinct trees at the bottom. I block in these trees with mixed long strokes and rounded short ones, pressing harder with the Hooker's green.

5

For the grassy areas coming down from the hillside to the lake I use a brighter green, viridian. Now it looks even messier, though admittedly quite pretty.

TIP

AS IN THIS PROJECT, DON'T BE HIDEBOUND BY THE FORMAT OF THE PAPER – IF YOU WANT TO DO A LANDSCAPE VIEW IN PORTRAIT FORMAT, DO IT.

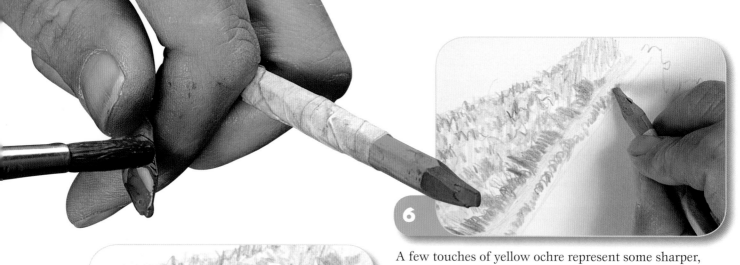

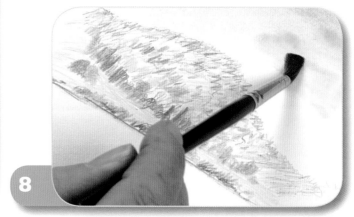

6

A few touches of yellow ochre represent some sharper, bushy bits on the lake side of the hillside, and I reinforce these with viridian. This is usually the stage where I don't want anyone to look at the picture – but I know what is going to happen next...

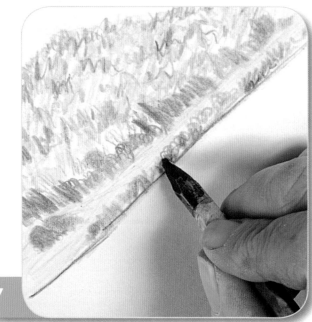

7

... and that was, that I touch in Mars black as lightly as I can along the very base of the hillside.

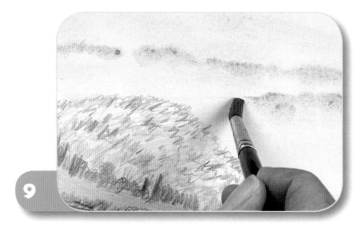

8

Now it was time to concentrate on the sky. I don't want to make it too bright at first, so I stroke some Prussian blue off a pencil with a No. 8 round brush and plenty of clean water (see top left), and spread it quickly onto the paper.

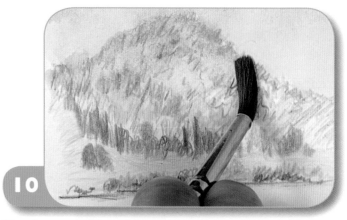

9

While this wash is wet, I put in more detail in the same way, using the same technique to put in rounded, shorter marks of blue-grey with the brush.

10

Now I start to dab and stroke the hillside colours with clean water, gradually merging them together and making the drawing into a painting in one go. The idea is not to make anything in the hillside too sharp or overpowering.

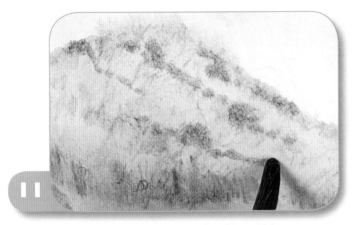

11

Again while the hill is wet, I tap a few bits of blue-grey from the brush on to the hillside to shape it and indicate its contours and the direction of the slopes. The colours soften on the wet wash and add a feeling of distance.

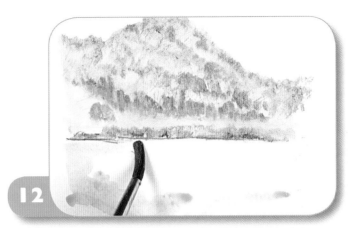

12

I don't want to repeat every single shape and colour of the hill in the reflection in the water, so I keep to the main colours and shapes. I start by brushing Hooker's green off the pencil for the main hill shape...

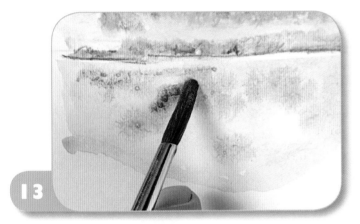

13

... and tap in some yellow ochre while the green is wet. This leads to a lovely merging of the colours. The all-important blue-grey gives the shapes of the contours and tree lines. This is not the water colour, but the reflection.

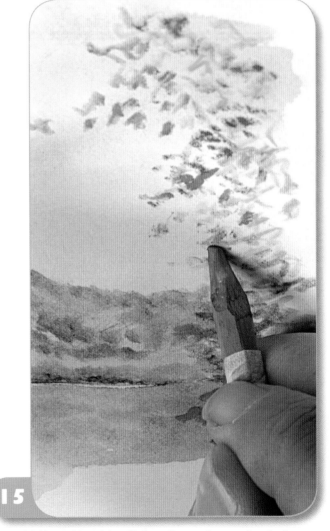

15

14

While the reflection wash is drying I touch in a few scribbles to represent leafier parts over the dry sky area; I just tap some viridian off the end of the pencil...

... and follow this with a little yellow ochre and cadmium yellow to give no more than an impression of foliage: the leaves and bushy parts are something to look through into the distance, not a solid mass, so I apply them sparingly.

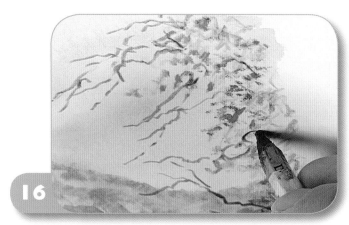

16

Next I put on a few lines of Mars black – I intend these not to be wetted with a brush, as they are to represent the harder lines of twigs and branches in among the bushy bits.

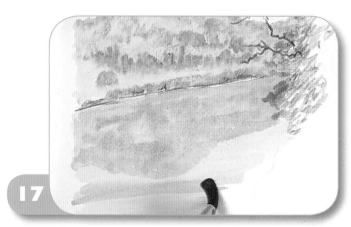

17

For the water in the foreground, I start by taking Prussian blue off the pencil with the brush and washing it all over the dry reflections – this doesn't disturb them, but makes everything blend together as one stretch of water. And hey presto – there we have a lake!

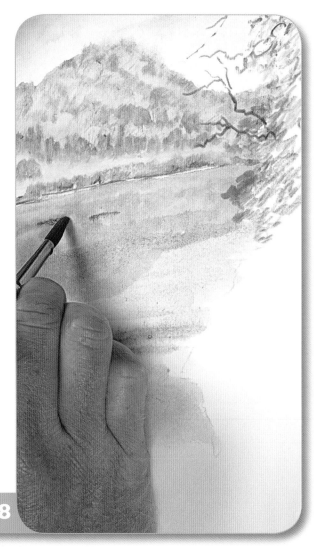

18

While the Prussian blue wash is wet, I put a few touches of blue-grey here and there in the reflections to give some darker shapes that add interest...

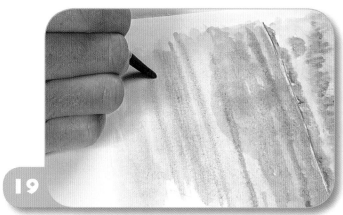

19

... and then carry on into the foreground area of the water, using different strengths of the blue-grey shade in long, horizontal strokes as I go.

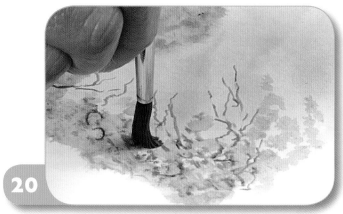

20

I then use clean water on the brush to wet the bushy parts, tapping with the brush tip – not everywhere, as I leave the black twigs and some of the pencil marks as hand drawing to contrast with the merged areas.

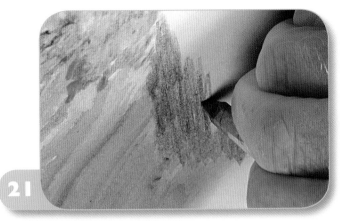

21

I tackle the bank in the right foreground next: I use Hooker's green and sap green for the most part and make the marks work by drawing the bank in the direction of the shape I want. A bit of yellow ochre comes next in an attempt to capture the light...

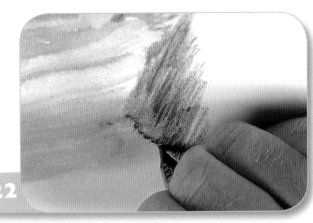

22

... and I finish this part of the drawing with Prussian blue, using it to make the margin with the water's edge, and also, stroking it on more lightly, to darken the bank.

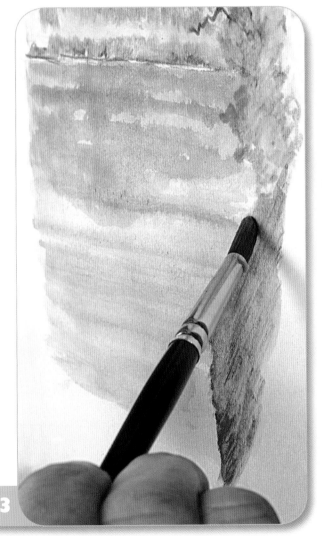

23

I next merge all the bank colours together with a clean wet brush, using the wet-into-wet technique as I went over the pencil marks. I work in the direction of the pencil strokes to keep the feeling of direction and shape.

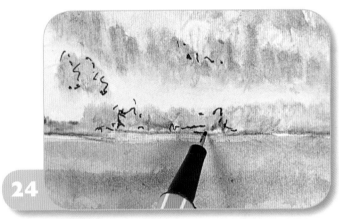

24

Switching to a fine fibre-tip pen, I put in a few squiggly marks to denote some tree and bush lines in the hillside and the bushy bits on the right side, plus a few lines on the lake. The pen is merely a backup to help highlight a few areas, and I make sure not to let it take over the picture.

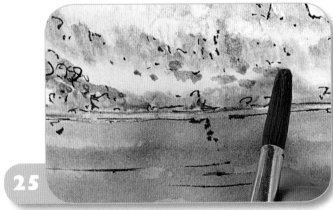

25

The very last stage is to take some permanent magenta off the pencil with the brush and drop in some of this shadow colour among the bushes and trees. Now, you have to admit it – aren't lakes simple to paint?

Pet Dog

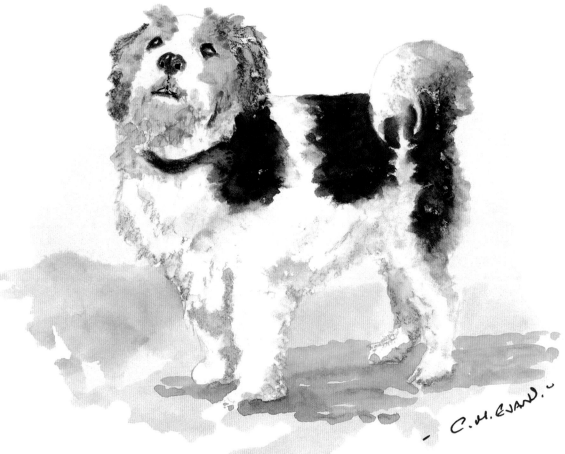

Whether your pet is a pedigree animal, or one of uncertain ancestry that has been rescued, it'll make an appealing subject. But people often don't even start to draw animals because of the problems they imagine go with trying to put in every hair and whisker; so my task now is to show you that it's possible! This is a particularly scruffy little dog called Sophie, trying very hard – and actually succeeding – to look cute.

I used tinted Bockingford paper for this picture, so that I could emphasize the whiteness of the fur by applying colour, not leaving it to the paper to do the highlights, as in other projects.

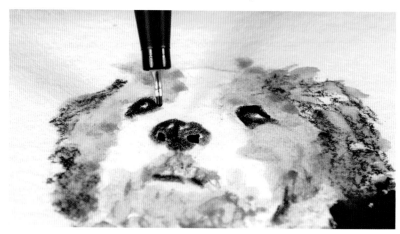

1

I start on the sides of the head with a few touches of yellow ochre, and then draw in the ears with some sepia. When drawing or painting your pet, think of rough, not straight, edges of hair and break up the outlines with scruffy, scratchy marks – this adds character.

2

Next I use Mars black to draw the black patches on the body, pressing harder for the more solid areas of colour, and more lightly for where the black fur meets the white. As before, I use scribbly, scratchy pencil marks, as the rather ragged, blobby results give the best indication of fur.

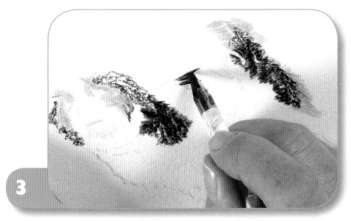

3

Continuing with the Mars black, I move on to the back: I press fairly hard but make sure there are small parts of the paper showing through.

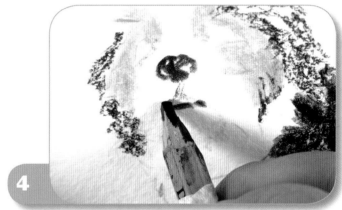

4

I use the same technique for the mouth, using the paper highlights to indicate a little moisture. Moving to the collar, I again press hard, but make a flat line, not a ragged one.

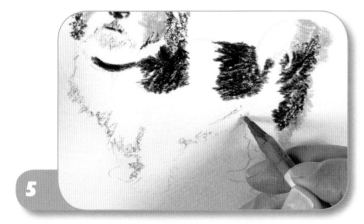

5

A lot of Sophie's fur is white – but as we know, not all white is white, so I add tints of blue-grey to the shadow areas of white fur underneath the body. When I get to the legs, I press a bit harder to deepen the shadow.

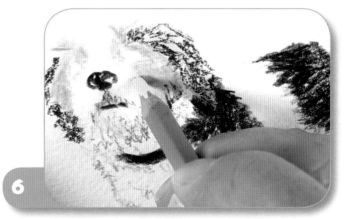

6

With the shadow parts in place, I then put in the extreme white of the fur with titanium white, scratching it strongly into the paper and working it into the other colours on the head, particularly where the light catches it on the top...

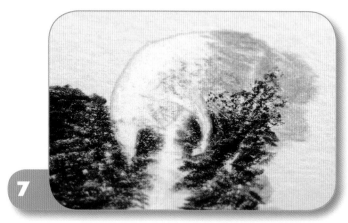

7

... and then do the same on the body and along to that cute little curl at the top of the tail. Where the white meets the blue-grey of the shadow colour, I work both colours together dry to knock back the tone.

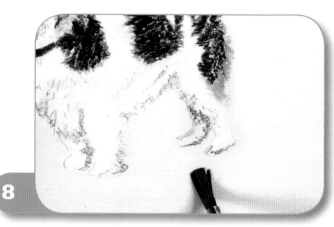

8

It's time for a bit of undefined background to put the dog into context. I wet a No. 4 round brush and take a very little cerulean blue off the pencil, then put this below the dog, being careful not to touch the drawn parts.

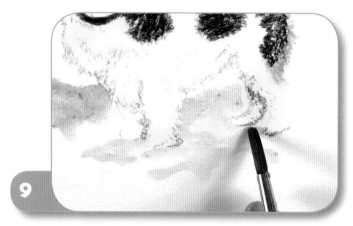

9

Then I dab some raw umber on to the blue while this is still wet, again taking the colour off the pencil with the brush. I work quickly, merging the two washes together.

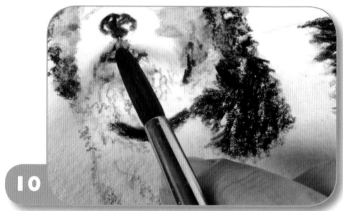

10

Cleaning the brush frequently, I use clean water to start merging and softening some of the pencil marks – the colours only at this stage, not the white – but not all of them: here I'm wetting the area of the mouth but not the nose, which stays as solid drawn pencil.

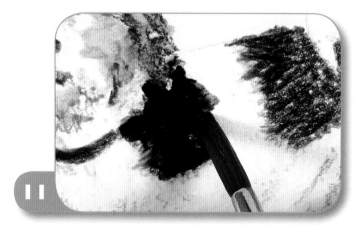

11

When I put water on to the black patches on the body, this makes them a deeper, more solid black, which makes the white areas really stand out in contrast.

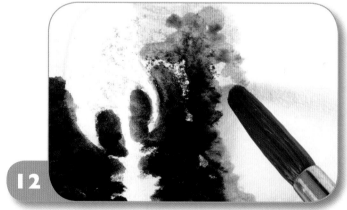

12

On the tail, I stroke the black very gently into the yellow ochre, merging and blending the colours to give a soft edge that still has the raggedness of the pencil marks.

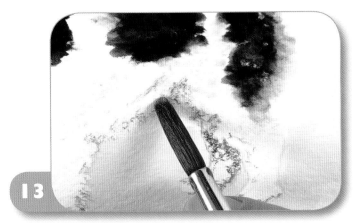

13

After rinsing the brush thoroughly to get rid of all the black, I use clean water to go into the white; I blend it a little with the other colours, and dab and tap into the blue-grey shadows to keep the effect of scruffy hair.

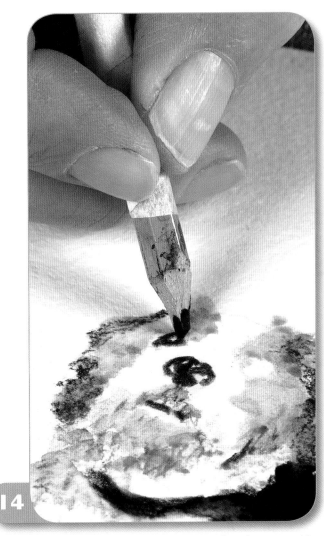

14

While all the wet areas are drying, I turn the picture upside down in order to avoid smudging them, and then work on the eyes with the Mars black pencil. I make sure to leave a catchlight in each eye...

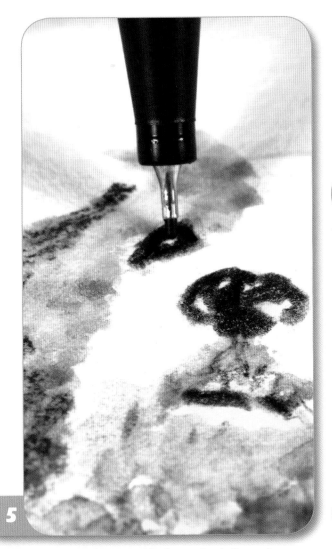

15

...and then, still working upside down, I reinforce the outlines with a fine black fibre-tip pen. I do the same with the pen on the nostrils and mouth.

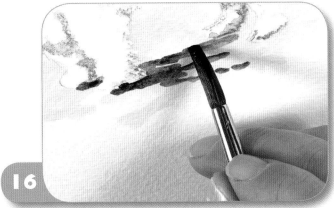

16

To finish, I stroke some Mars black on to the brush and add some shadow beneath the body to anchor it to the ground and stop the dog floating up into the air. And there we go – Sophie in all her glory!

Mallards

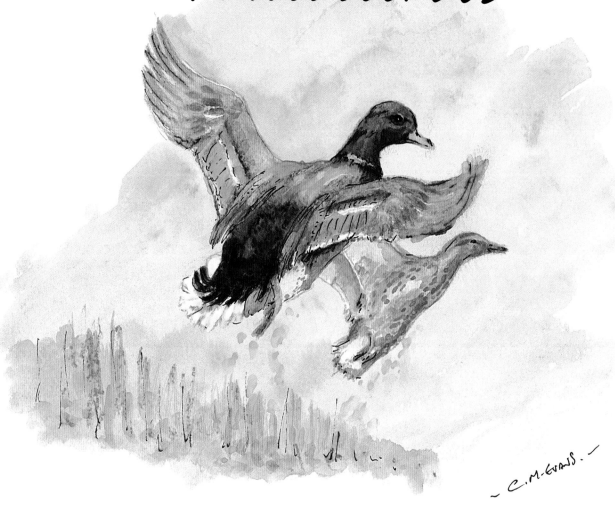

~ C.M.Evans.~

I always find it strange that the birds I see most often when I'm walking through the fields are the most beautiful ones. Here are a pair of mallards, startled into flight from the water – perhaps by me.

I used cool grey pencil for the initial drawing on oatmeal-tinted paper, and left in some small missed lines as usual; these will disappear when I stroke on water, and they also add character and movement to the birds.

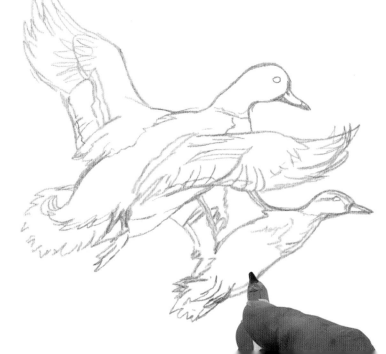

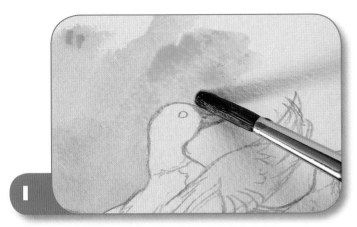

With the pencil drawing of the birds completed, I start on the sky area. Taking some Prussian blue off the pencil with a No. 8 round brush, I quickly apply a wash, taking care not to go over the outline marks of the birds.

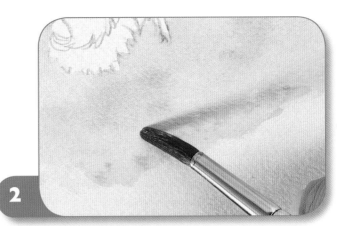

While this is still wet, I take a tiny touch of olive green off a pencil and drop this into the bottom part of the sky, as an indication of the ground from which the birds are rising...

... and while this blue-green blend is still wet, I go in with the olive-green pencil and draw in a few lines for grasses. Because I have drawn dry on to wet, when the washes dry these marks will be immovable under further washes.

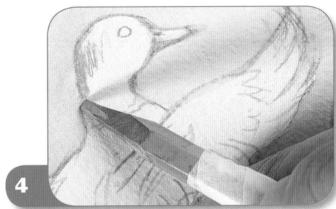

For the head of the drake, I start with manganese blue pencil, applied lavishly; the male of the bird species is often highly coloured.

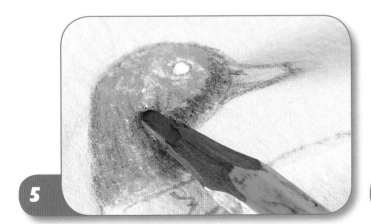

I then scratch over and into this, first with Hooker's green and then with some blue-grey in the shadow areas. At this stage it looks a mess, but trust my artistic instincts.

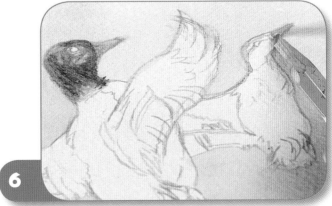

I draw on small strokes of yellow ochre for the beak, and then do the same for the female's. I finish this stage with a tiny touch of sepia at the end of both beaks.

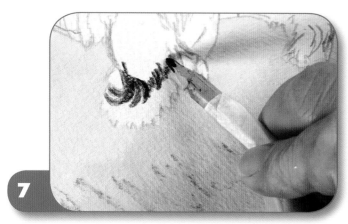

7

I use Mars black on the drake's tail, working positively and strongly for the most part, and then feathering less hard as I come up towards the wings.

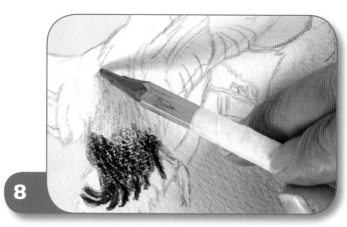

8

Next I put in some blue-grey, starting at the top of the back and working up the body, only this time applying it much more lightly than I did with the black – just stroking the pencil on.

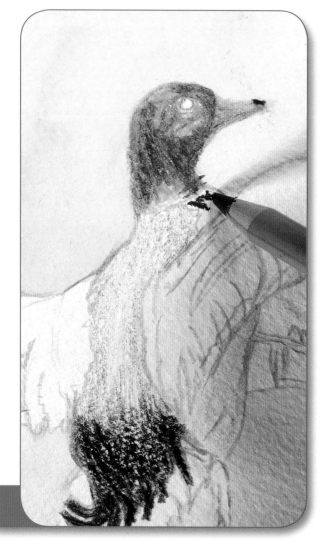

9

Using quite hard pressure, I make small marks of sepia on the drake's breast just below the neck with the tip of the pencil. I then reduce the pressure and colour on the shoulder, using the side of the pencil.

10

Using manganese blue again, I put some marks on to the female's wing – because she's further away than the drake, I go more lightly than I did on him. I add some stronger marks on the drake's wing.

11

For the white of both tails I apply the titanium white pencil quite strongly, again using more pressure on the nearer drake; then I work it into the back of the drake's wings, once more quite firmly.

12

I start the outer edges of the drake's wing using a cool grey (the colour used for the outline drawing), and then reinforce this with blue-grey. To give a feeling of movement to the wings, I keep the strokes fairly wispy.

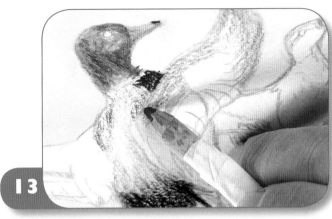

13

After putting some Vandyke brown on the drake's wings, I switch to yellow ochre for the legs of both birds and for an overall scribble on the female's head, body and wings; on the latter, I reinforce this with a touch of raw umber. A little Mars black on the wings, and that's done.

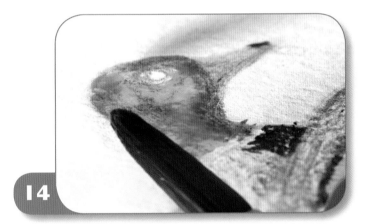

14

Now it's time to start pulling everything together. Using clean water on a No. 8 round brush, I merge the colours on the drake's head: this is a fabulous feeling, as a scribbly drawing becomes a painting.

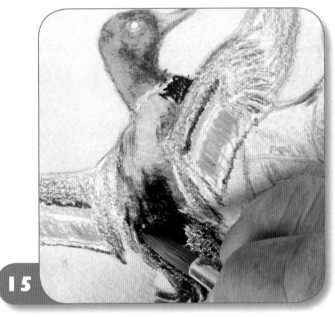

15

Bluey green is a very strong colour, so I make sure to wash the brush out thoroughly before I move on: all the colours are waiting, so I work with impunity and, above all, don't fiddle. I work into each colour block by block, merging in places, and washing out the brush between colours.

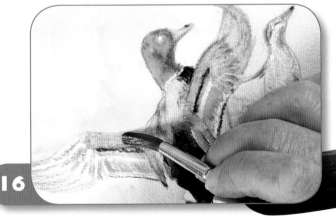

16

When it comes to wetting the wings, I make the brushstrokes follow line – not vertical or horizontal – and tail the strokes off before I get to the wing tips, keeping these parts very wispy with light touches of the brush.

17

When I come to the tail, I'm careful to keep the intense white of the pencil clear of the black areas just next to it. I also make sure not to bring water onto the legs.

18

Moving to the female, I dab water on to the head and body with quick strokes, just to merge the colours and settle the base. Because she is further away, she requires less detail than the drake.

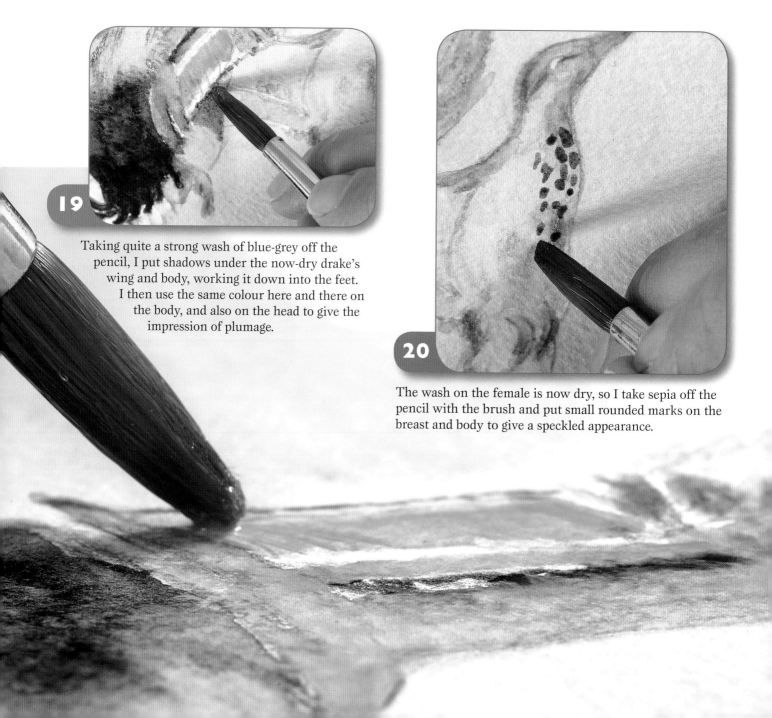

19

Taking quite a strong wash of blue-grey off the pencil, I put shadows under the now-dry drake's wing and body, working it down into the feet. I then use the same colour here and there on the body, and also on the head to give the impression of plumage.

20

The wash on the female is now dry, so I take sepia off the pencil with the brush and put small rounded marks on the breast and body to give a speckled appearance.

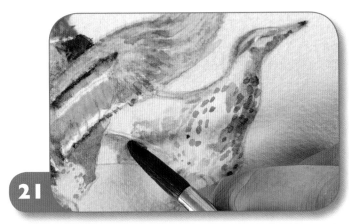

21

When the sepia is dry, I take a little blue-grey off the pencil with a lot of water and add light shadows to the female as I did to the drake; because she's further away, these shadows should be paler and less detailed.

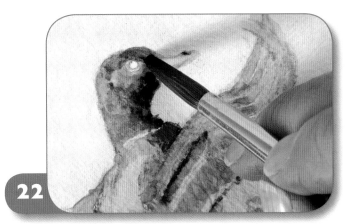

22

Now both birds are painted, I can check for colour strength; I add a little Mars black to the drake's head with the brush, just dabbing on tiny marks to darken what's already there, not to make a solid black.

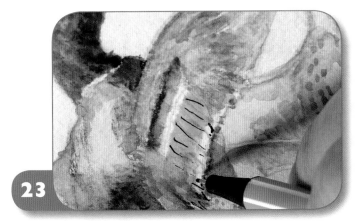

23

Using a fine black fibre-tip pen, I add some very small touches to tighten things up on the birds – mainly to suggest a few bits of plumage and the edges of the legs, both using broken lines. I also put a few light strokes to reinforce the upright growth of the grasses beneath.

TIP

ALWAYS REMEMBER THAT WATERCOLOUR PENCIL COLOURS CAN LOOK DIFFERENT APPLIED DRY AND WET, SO TRY THEM OUT BEFORE YOU START.

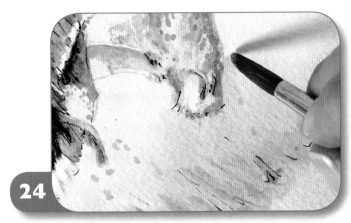

24

The mallards have just taken off from the water, so I take some bright manganese blue off the pencil and put in a few drops coming from the birds' legs and bodies.

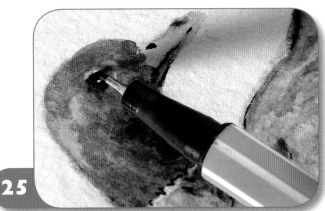

25

To finish, I go back to the heads with the pen and add the last details: the eyes with catchlight, the nostril and beak, and a few bits of plumage at the neck. And that's it.

sketchbook: Tuscan Village

C. A. EVANS.

A few friends chatting in a courtyard give scale to the trees.

Buildings nestling in the trees on the hill.

I sketched this huge pizza oven while waiting for my meal to emerge from it.

C.M.Evans. 2002

This is pure sketchwork – both the plain sky and the merest suggestions of people put the focus onto the houses.

Into the Village

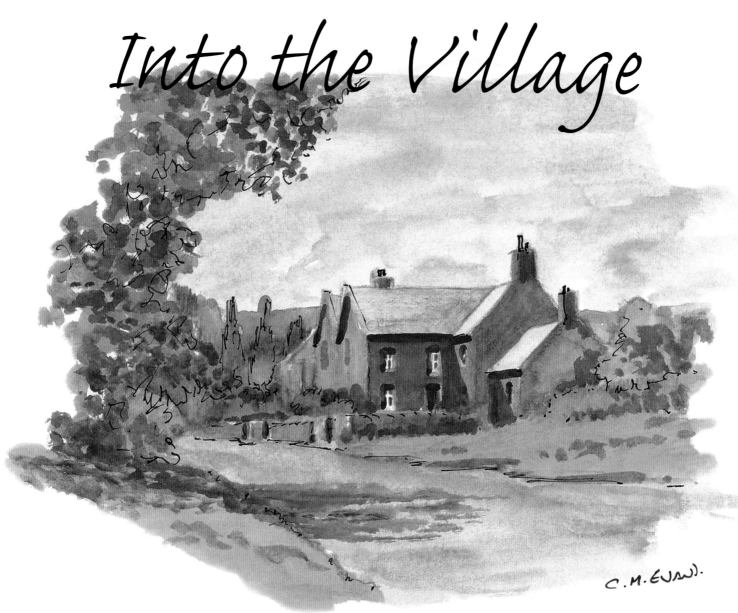

C.M.EVANS.

This painting was done on the roadside going into a village; just past the old house in the foreground you can make out the rough shape of another house – which happens to be my own. So you don't have to go far to find subjects to draw and paint with watercolour pencils – just pop outside and sketch what's around you.

I used light grey pencil for the initial drawing in my sketchbook; this kind of location work will always have a few mistakes and extra lines in it, but once some water is applied, these disappear.

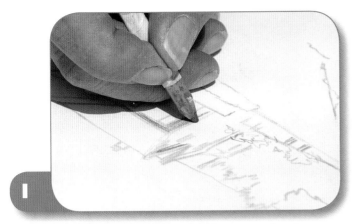

1

In this particular village, all the buildings are a lovely sandstone colour, so for the main building I use raw umber for the walls in shadow and yellow ochre for those in sunlight – just lightly scribbling on with the pencils.

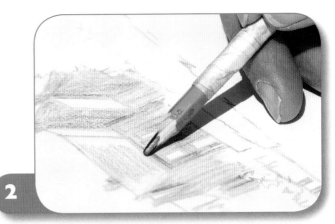

2

For the roof I use blue-grey, putting on the colour with side-to-side strokes of the pencil. This is one of those pictures where I find myself drawing for a long time before the water finally pulls everything together.

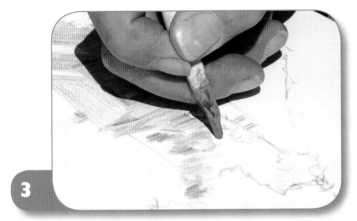

3

For the distant trees and bushes I start with sap green, scribbling on a few marks here and there. To show different types of foliage, such as conifers and shrubs, I vary the green and switch to Hooker's green and viridian.

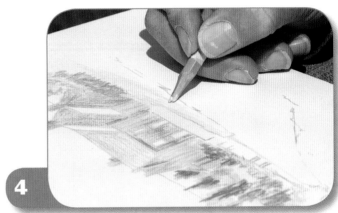

4

After putting some touches of cadmium yellow among the greens for front gardens, I use the same colour for the foreground grassy verges, then go lightly over the top of this with viridian, ready for mixing with water later on.

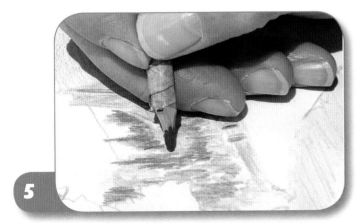

5

I draw the walls with the same colours I used for the buildings, then use some Prussian blue among the far trees – this might seem a strange choice of colour, but when wetted, it'll bring in a wonderful sense of coolness and recession. All this preparation will be worth it!

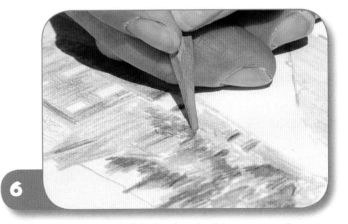

6

There are some very bright bushes in this scene, so I use cadmium orange to dot them in. To finish the drawing part, I go back to the Prussian blue to put in the window panes (though not the frames); I work these in quite strongly, as I probably won't wet them.

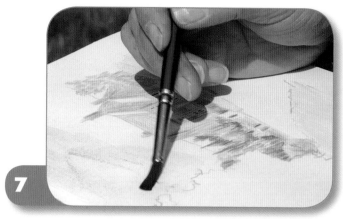

7

Now for the sky. I apply this by brushing the colour off the Prussian blue pencil with a No. 8 round brush and clean water, and simply brushing it on. There's a lot going on below, so I don't want to make the sky vie for prominence – a few quick sweeps of colour do the trick.

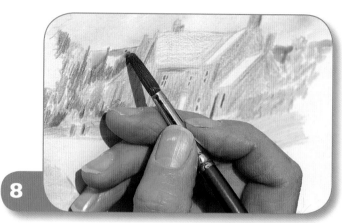

8

While the sky is wet, I mix Prussian blue and blue-grey by taking the colour off one pencil and mixing the two on the other pencil. I then use this for the distant hills, which are quite a long way off. Here I'm just filling in my outline from my initial drawing.

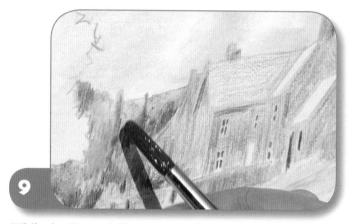

9

While the distant hills are wet, I clean the brush and apply water to the furthest trees and shrubs – look how the water starts to pull the scribbled marks together.

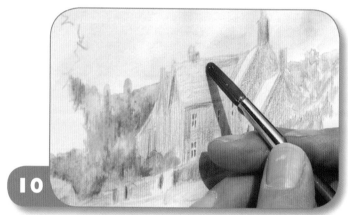

10

The sky's almost dry now, so I rinse the brush and block in the roof with clean water. This side is in shade; I leave the side catching the light as the colour of the paper.

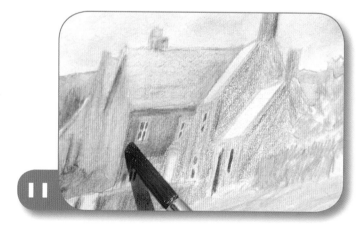

11

When I start work on the building, I know I need to keep the colours moving – old buildings have variations in colour and the roof lines may sag, so I don't use a straight edge and actively aim to have varied tones on the walls.

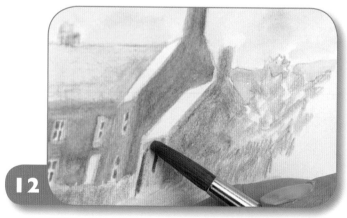

12

Without adding any extra colours, I sweep the ochre and umber of the walls across the bottom of the roof line in the nearest building, to give a good rich colour.

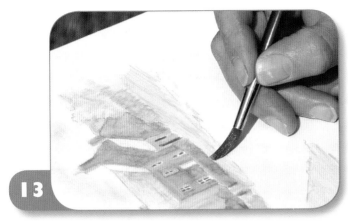

13

After cleaning the brush once more, I carry on to the bushy areas and hedgerows with one sweep, then rinse and merge the colours together on the foreground verges – what a difference this makes, and how different from the shrubbery this new colour is.

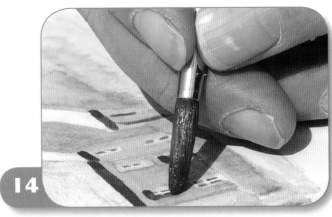

14

Taking my shadow colour of permanent magenta off the pencil, I now put in shadows on the roof lines, eaves, doorways and windows. Applying shadows to one side of the building warms it up, and I add shadows to the other walls and to the grass verge.

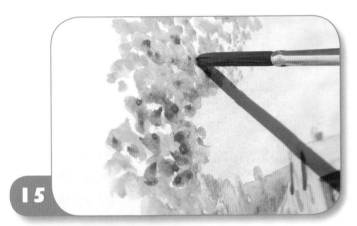

15

For the main tree on the left, I start by tapping on leaf shapes and clumps with Hooker's green, then use a dark blue-grey, also taken from the pencil, to give a feeling of depth.

16

The tarmac road is blue-grey; I stroke the colour on with the brush, and then go back to permanent magenta to carry on the dappled shadows from the verge. A few marks with a fine black fibre-tip pen, and it's done – at least I don't have to go too far for a warming cup of coffee...

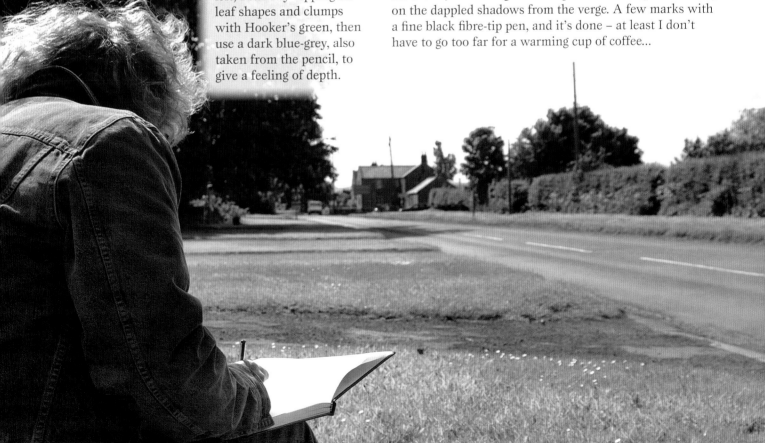

Dutch Barn

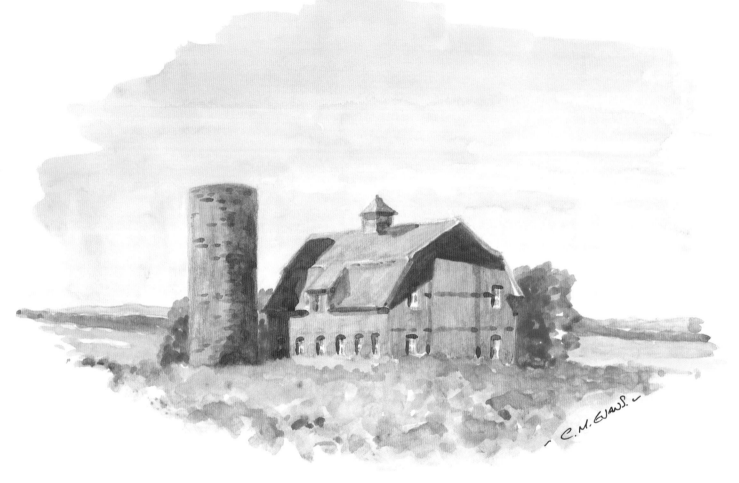

The classic American Dutch barn is a structure with some weird and imposing angles. The most difficult part of getting the angles correct here is that my artist's eye is telling me they should be straight when actually they aren't. In the initial drawing I've made a couple of straight lines at the side of the barn to help me get the windows at the correct angles and proportions, watching the roof line; this fairly steep angle provides a feeling of recession.

I used cool grey pencil for the initial drawing on sketchbook paper and left in some small missed lines and angles; I don't need to rub them out before going any further, as all I have to do is stroke over the marks with water and they'll disappear anyway!

1

'Colouring in' the initial drawing may sound like a child's exercise, and to a great extent that's what it is – but you still have to work carefully. I start by using a little olive green pencil on the roof, making sure I go all the way up to the outline pencil lines.

2

For the barn walls I use light red, a lovely salmon-pink colour, especially with a bit of titanium white pencil added. People ask whether I was taught colour mixing; I wasn't, but have learned it by experimenting and a lot of practice. I then use the same colours for the tower.

3

On the right of the tower I stroke in some blue-grey pencil, with the strokes heaviest on the side and getting weaker as they approach the centre – this produces a round feel on the tower. There's no detail of the brickwork at this stage.

4

To give the barn some form and dimension, there needs to be a dark side and a light one; a little blue-grey does the trick for the dark side, but I take care not to press this pencil too hard into the light red.

5

Don't paint sash windows with net curtains – and don't even paint the frames! All I do is put a couple of blue blobs of pencil marks inside the frame, using the white of the paper to make the frames themselves and the sashes.

6

With the buildings filled in, it's time for the sky, for which I use manganese blue, a particularly bright blue. I take the pigment from the pencil with a No. 8 round brush and go carefully round the building.

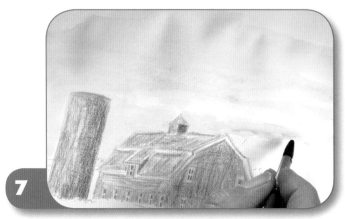

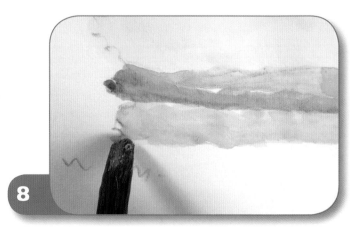

While the sky wash is still damp I use more manganese blue on the brush to paint in the distant hills, using a strong wash for those nearest. I then take some blue-grey on the brush and drop this on top of the blue, to tone down the brightness and bring the hills even closer.

From now on, I'm applying all the colour from the brush. After leaving the sky wash for a couple of minutes to dry more, so that it doesn't crinkle, I add some Prussian blue forward of the middle distance, and then some cadmium yellow on top of this towards the foreground.

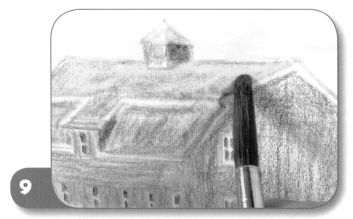

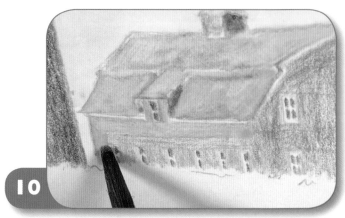

Now I'm going to wet the pigment marks on the building with clean water and the brush – this is where it all starts to come together – and as always, I plan to wet the light parts first, so I can carry the dark into the light. On the roof I make diagonal strokes in the direction of the slope…

… and then wash the brush thoroughly before I start working on the red of the barn walls. I leave a tiny strip of white paper where the roof meets the walls, to show how the light catches these parts.

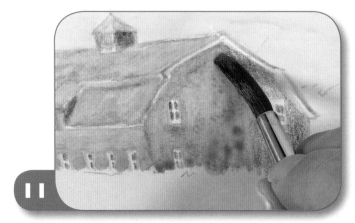

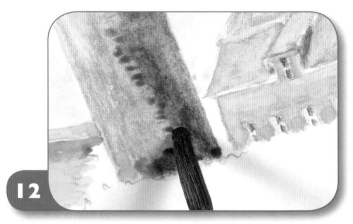

On the side wall, I merge the colours together to produce a darker tone. Remember that this is an old building, so it doesn't want to be all flat and perfect: in order to get a varied effect of texture, I pick up paint from a wet area and then put it on to the dried parts.

On the tower, again I wet the lighter side first before dealing with the darker areas; I then stroke the dark side gently into the light one and smooth the edges where the colours meet with clean water so as to give a rounded effect. I now leave all this to dry.

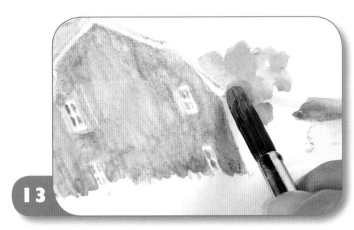

13

For the trees on either side of the structures, I take viridian pigment off the pencil with the brush and apply it in intentionally scrubby lines, taking these carefully up to the building's sides. The strong hues show just how powerful a medium watercolour pencils can be…

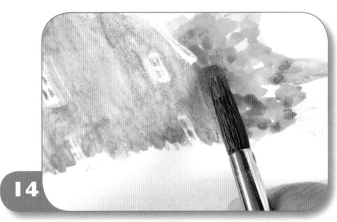

14

… but even so, I want to strengthen the trees. I mix manganese blue and blue-grey from the pencils on to the brush, and then apply this to the darkest point, where the bush meets the building, to give a strong framing edge.

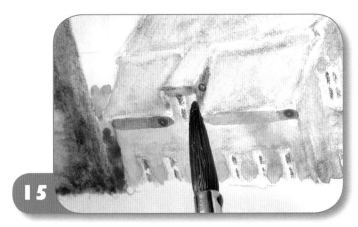

15

For the shadows on the barn I apply a warm permanent magenta below the roof, to anchor it to the walls. A tiny touch of the same colour on the top and down the left of each window frame makes them appear recessed into the walls. I then use the magenta for a few lines along the walls to indicate that the barn is a wooden structure.

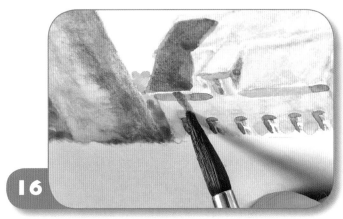

16

The tower casts a shadow on the barn: be brave, paint on the magenta liberally, and don't worry – the more you prevaricate and fear the action, the more you may spoil everything you've done so far. Don't forget the shadows from the top window and the top of the roof.

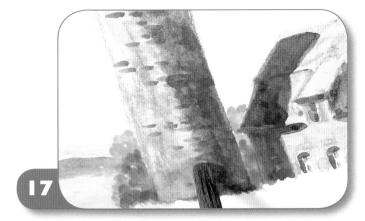

17

Now I reinforce the darkest shadow areas with blue-grey over the dry magenta. To give the impression of brickwork, I mix light red and raw umber off the brush and put in a few touches here and there – to be realistic, these should not be too many or too regular.

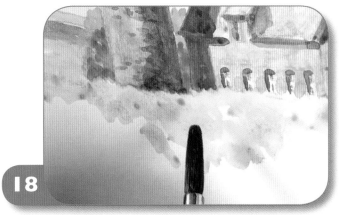

18

For the grass, I take viridian from the pencil and apply it quickly, just leaving a little of the white paper surface showing through. I then finish with a few bits of shadow using permanent magenta. And there we go – a proper old Dutch barn!

Church

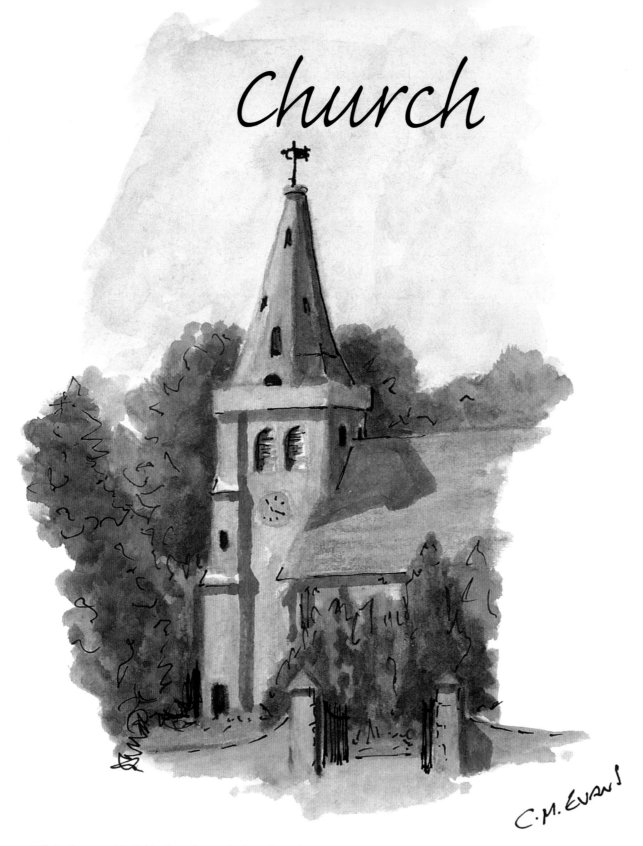

C.M. Evans

This beautiful little church in the tiny market town of Warkworth has been painted by many famous artists – and now it's my turn! I decided not to attempt the whole building, but chose to do a little vignette based on the spire and tower, which allows me to concentrate on the tone and colour. A useful tip here is to leave open any gates in your view, as this leads the eye into the picture.

I start with an initial outline drawing in blue-grey pencil, including some framing conifers and shrubs. To make sure the two windows in the tower look straight, I use a couple of guidelines to make sure the tops and bottoms of the windows align.

On the lighter, left side of the spire, I use yellow ochre pencil, and on the shaded side I use raw umber; however, this is an old church with weatherbeaten stone and the lines aren't all dead straight – so I tone the umber into the ochre where the edges meet.

Next I bring the ochre and umber down the respective sides of the tower, working around the clock face and windows. For the roof I use side-to-side strokes of blue-grey, and go over them lightly with strokes of raw umber.

Because they were dark, I didn't leave the windows in the spire as blank paper; I put them in now with strong blue-grey. I then use Prussian blue for the clock face.

I start the trees behind the church with scribbles of yellow ochre. Into this I then add Hooker's green, being careful to go only up to the church building, not over it.

For the conifers in front of the church, I first scribble on some yellow ochre, followed by strong, hard Hooker's green, again going carefully round the gateposts.

Church 79

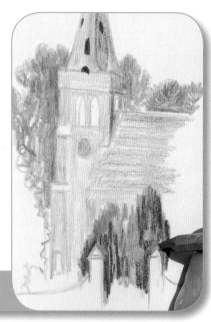

Over these colours I then go in quite hard with blue-grey. Already these trees look darker and further forward in the picture than those behind the church, even with the ochre showing through.

The tree on the left is a lovely copper beech, and for this I start with short, rounded brushstrokes in cadmium red; I then partially cover them with a little blue-grey, and then put some burnt sienna on top of the other two...

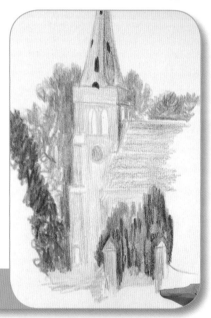

... followed by a touch of yellow ochre at the base and between the gateposts. For the posts themselves I use yellow ochre for the sunny side and raw umber for the side in shade, just as for the tower and spire.

For the bright, cloudless sky I take Prussian blue off the pencil with a No. 8 round brush and paint it quickly on the paper; this is a vignette, so I don't try to cover everything. Loading the brush with clean water, I tap it on to the background trees so as to merge the colours, again working round the shape of the spire.

Making sure the water on the brush is clean, I then go into the three colours on the copper beech, tapping the brush on and moving the colours around to make a vivid colour mix.

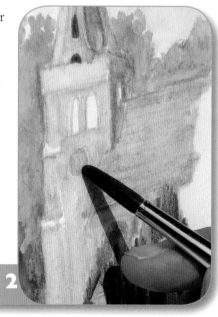

Again using clean water, I work down the church from the spire as I did for the drawing part, merging and blending the pencil colours. The colours on the roof mix and blend to make a lovely slate grey, and I solidify the colour on the clock face.

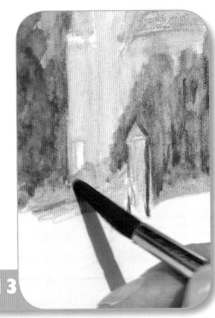

I now move on to the conifers and shrubs in front of the church, each time recharging the brush with clean water. When I paint the gateposts, I use the brushstrokes directionally, working vertically for the posts and horizontally for the walls.

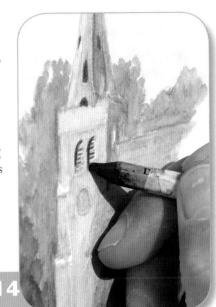

The windows in the tower have green shutters: I use a Hooker's green pencil for this, then switch to Mars black to show the recesses strongly. I use the same black for the lower window and door in the tower.

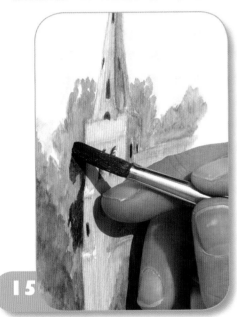

For the darkest shadows where the conifers meet the church, I stroke permanent magenta off the pencil and then mix it with Mars black. I also put a little of this into the copper beech, but not too much.

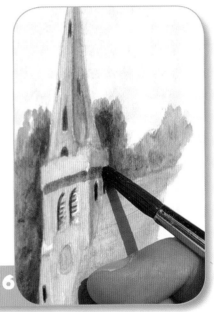

I use a lighter version of this shadow mix for the shadows on the church, from the spire on to the roof and into the conifers around the gateposts. I then let everything dry before putting in the final touches.

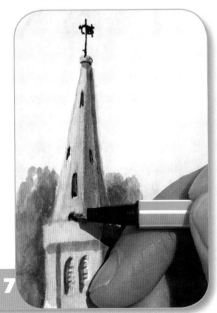

Using a fine black fibre-tip pen, I start by drawing in the weathervane on the spire. I then edge the windows, put hands and numbers on the clock face, add some fairly large iron gates, and finish with a few squiggles here and there on the trees and grasses. And there's a vignette.

sketchbook: Sea

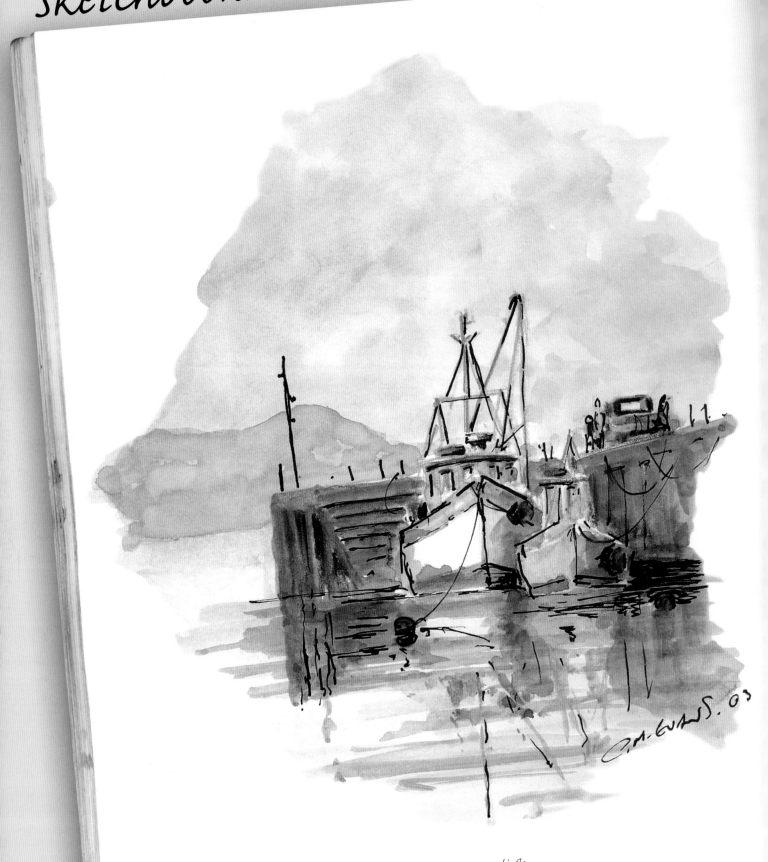

Don't just stick to one position when sketching — get in close to some subjects...

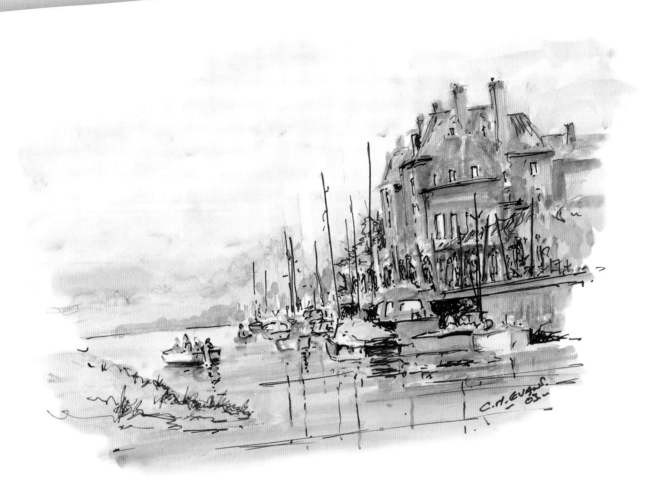

... and pull back to include more of the surrounding background in others.

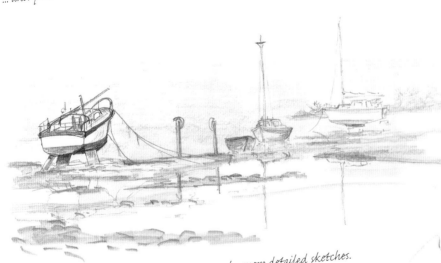

Working in monochrome allows me to make more detailed sketches.

Boats in Harbour

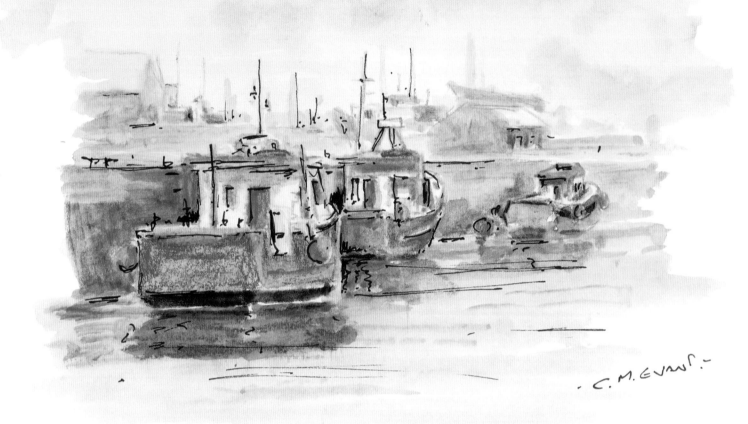

For this project I went to Amble, a little fishing port near where I live in Northumberland. Harbours can look rather complex, but I wanted to concentrate on the boats and not get pulled into all the other things that go on in the actual scene. In the distance, the boatyard can be an impression of blocks and a few sharp bits – you can tell by all this terminology that I'm a very nautical person – with verticals for masts; verticals aid any picture by creating recession.

I'm using a hardback sketchbook for this project, 'hardback' being the important word, because a hardback book will stand any amount of hammering on location and in transit, and because it is properly string-bound, you won't lose your valuable sketches and artworks.

1

I start by filling in the nearest boat with cadmium red, just like in a child's drawing – this is the fun bit! As with any pencil work, the harder you press, the darker it gets – with watercolour pencils, the more pigment that is pushed into the paper, the stronger the tone will be.

2

For the boat on the right I use a light blue pencil; throughout this drawing part of the project I'm leaving the white of the paper to stand for the white parts of the picture.

3

A touch of light red is useful for the waterline of the blue boat. Next I switch to Vandyke brown for the doorways of the boats.

4

I then apply a touch of blue-grey for the windows.

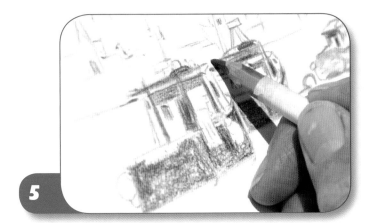

5

The initial drawing was done in a light gunmetal grey, and I return to this colour to put in the various bits of fishing gear on the boats. Don't be tempted to overdo this because too much detail will spoil the picture.

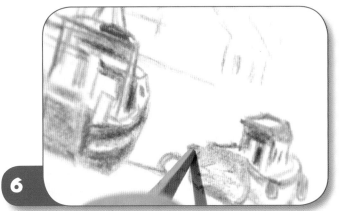

6

For the buffers at the tops of the boats I use yellow ochre, and then apply orange for the buoys, going over this with cadmium red. At no point do I go into too much detail with any of the pencils – remember, I'm just looking to achieve an impression of the colours and the shapes.

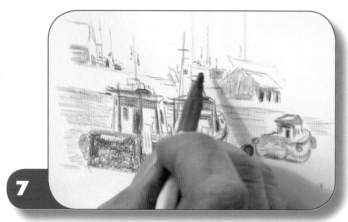

7

I keep to this lack of detail when I add a few buildings in the background, otherwise they might come too far forward in the picture. For this I use raw umber, and I make very light strokes for the harbour wall using the same colour.

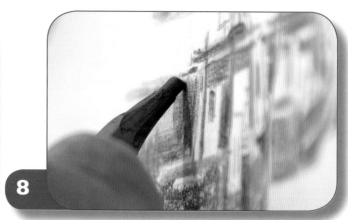

8

I go over the harbour wall again, this time with an equally light application of blue-grey; however, I press down hard at the base of the wall to make a stronger tone and indicate the shadows cast there by the boats.

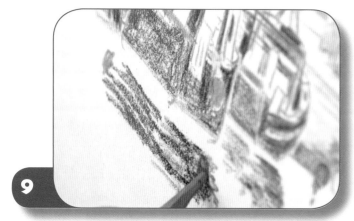

9

Don't forget that water has reflections of what's on it. Here I'm not going into any details of the boats, just repeating the colours in blocks for now.

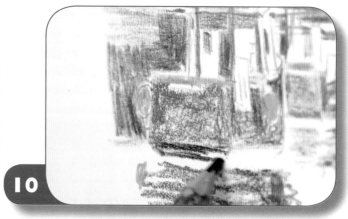

10

For the base of the main boat I use strong strokes of Mars black, and then go on to add this colour to all the boats and the reflections on the water.

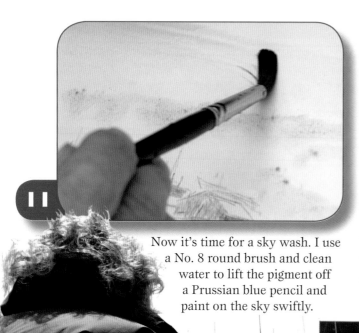

11

Now it's time for a sky wash. I use a No. 8 round brush and clean water to lift the pigment off a Prussian blue pencil and paint on the sky swiftly.

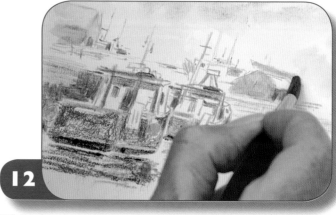

12

While the sky wash is still damp I clean the brush and take it over the distant buildings and make them merge into the general mêlée of the background.

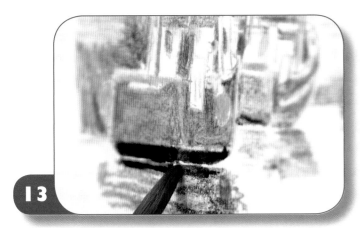

13

Once more wetting the brush with clean water, I start to stroke it on to the colour of the boats – and suddenly the drawing becomes a painting! I make sure to take the colours down into the reflections as well, wetting each section in this way.

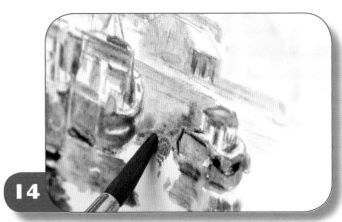

14

Now I move on to the all-important shadow cast by the boats on the harbour wall, making this strong and dark, while leaving little bits of white paper showing, to capture the light between the boats and the wall.

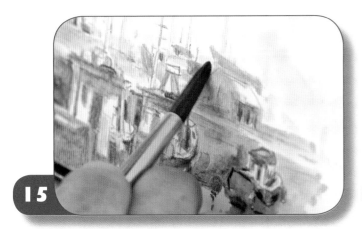

15

Recharging the brush with clean water, I go over the marks for the bits of 'gubbins' on the tops of the boats – this being a technical term used by all seafarers.

16

For the sea, I take the pigment off the blue-grey pencil and stroke the wash over the reflections of the boats, glazing the colours together to give a watery impression. I strengthen the colour here and there to indicate ripples.

17

I use the same technique for the shadows on the harbour wall, and add a few areas of shadow here and there on parts of the masts and buoys. With the washes finished, I then let it all dry completely. While it's drying I take the time to look at the picture to see where I feel it needs the addition of a few finishing touches.

18

To finish, I apply a few fibre-tip pen lines to sharpen up the harder lines and pull things together, but without including too much detail or too many extraneous features – any pen will do, so long as it doesn't make blots. And there it is: the harbour with a traditional Northumbrian cobble (pronounced 'coh-ble') fishing boat in the foreground.

Lighthouse

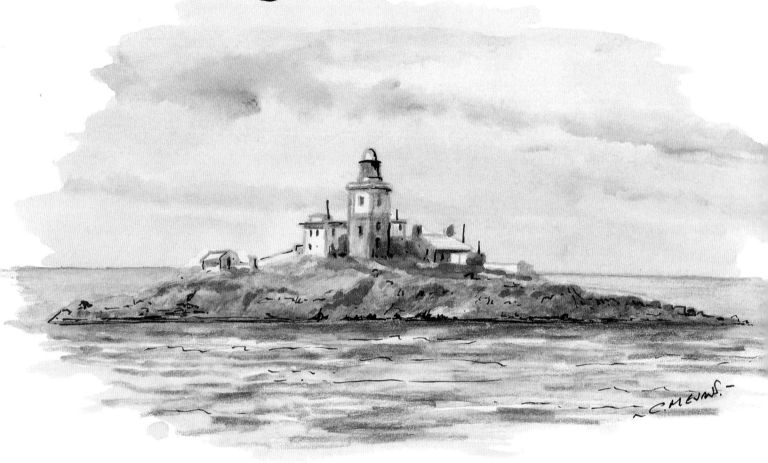

This little scene is Coquet Island, off the Northumberland coast; as well as having a lighthouse, it's a protected nature reserve, and normally no one is allowed on the island apart from the wardens. I've been lucky enough to be given permission to go on the island, and it's amazing how much wildlife there is on such a small piece of land.

I used cool grey pencil for the initial drawing on sketchbook paper. Apart from getting the basic shapes down, I didn't bog myself down with details – on this part of the coast, the wind means you don't want to stay in one position for too long!

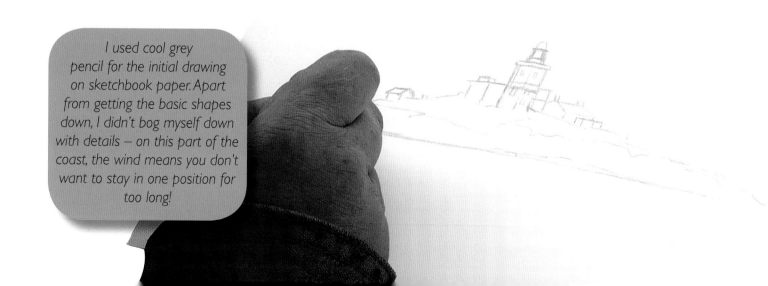

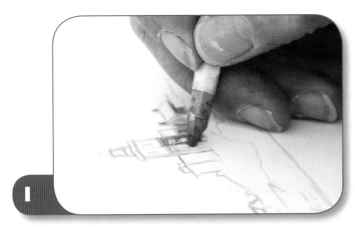

1

There's quite a lot of white on the lighthouse, so I start by colouring in the bottom half of the building with raw umber. For the darker sides I simply press on harder than I do for the lighter sides.

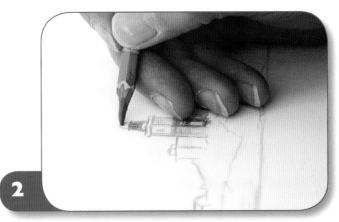

2

After putting a little cadmium red on the lighthouse top, I add some of the shadowed areas. I use blue-grey to get the right blueish tint over the white parts of the buildings, working lightly all the time.

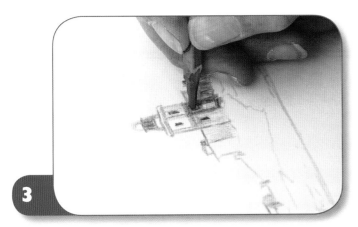

3

For the little windows I press the pencil harder on the paper – the lighthouse is a long way away, so I'm not concerned with getting in too much detail. For once I'm not going to start the shadows cast by the building by painting them: still using a fair bit of pressure, I draw them.

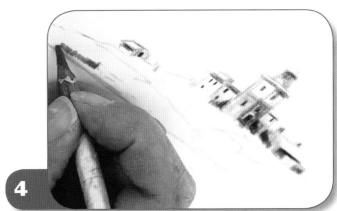

4

The shadows are important, as they show how the buildings are separated from each other. I then continue with the blue-grey pencil, this time starting on the darker stony parts of the island itself, just setting their positions.

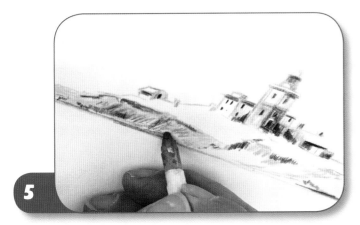

5

I then add some touches of yellow ochre for the lighter stone areas, just scribbling and not fiddling – I'm here to have fun with the drawing! As I fill in some darker parts with raw umber, I work into the edges of the yellow ochre so the two colours will merge when I add water.

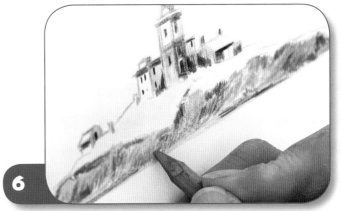

6

To finish drawing this part I put in a few touches of burnt sienna, which has the effect of warming up the whole area. If it all looks like a patchwork of colours at this point, that's because it is.

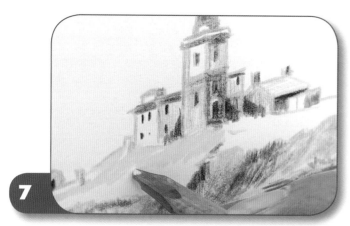

7

When I come to painting the top of the island, I start by covering most of the area with cadmium yellow and then scribble sap green lightly over this, allowing the yellow to show through here and there.

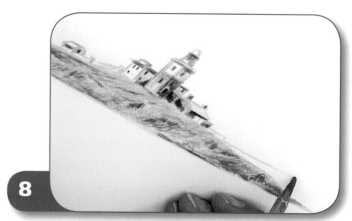

8

This drawing is about the lighthouse and the island, so when I move on to the sea, I'm careful not to make it the dominant feature. I use blue-grey with the side of the pencil, creating a feeling of movement by leaving quite a bit of white among the lines and pressing harder in parts.

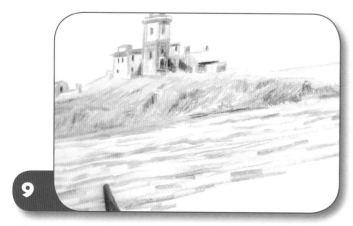

9

The sea is never just one colour of blue – there's lots of variety there – so I add first Hooker's green and then Prussian blue. Again I'm just putting in strokes of colour and not trying to block in over the white of the paper.

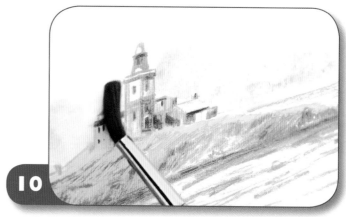

10

The sky has the same role as the sea – purely as a backdrop – so I don't spend too much time on it. First of all I take yellow ochre off the pencil with a wet No. 8 round brush, and paint it on as the base of the sky.

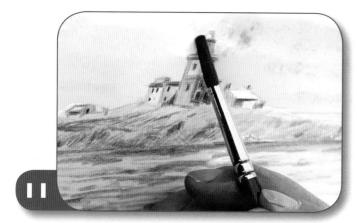

11

While this wash is wet I repeat the process for the top of the sky, this time using Prussian blue; I also work into parts of the yellow, just dropping in a few blue patches to give variety. And that's it for the sky – I now let it dry.

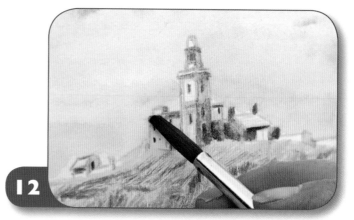

12

Using clean water, I start to dab the brush on to the pencil marks on the buildings, making sure not to drag the colours over the white parts, which catch the light.

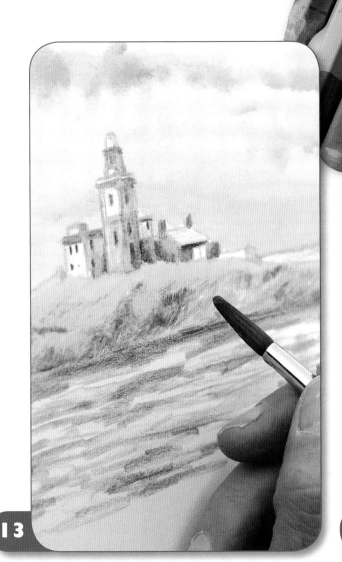

13 When I come down to the rocks and grassy areas of the island I continue to dab the water on, rather than stroke it; I also leave some parts untouched by water, as the hard pencil marks work to show contours and undulations. Again, I let everything dry at this point...

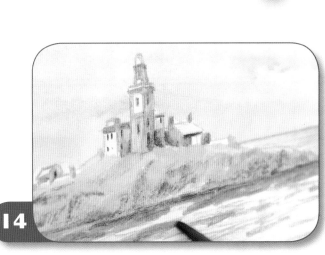

14 ... and when it is dry, I again work on the sea. In the distance, behind the island, I use a lot of water to keep the colours weak, and then less as I come into the foreground. I still leave white paper showing through and use uneven lines to show the movement of the waves.

15 For the larger shadows I take permanent magenta off the pencil with only a little water; although I go over the drawn blue-grey shadows, I try not to drag the colour with the magenta. A few shadows on the ground help to reinforce the contours.

16 When all the washes are dry I add a few more details with a fine black fibre-tip pen: some short, rounded brushstrokes for craggy parts of the island, some lines for the windows and building details, and then a few broken lines in the sea. And there's your lighthouse!

Bridge

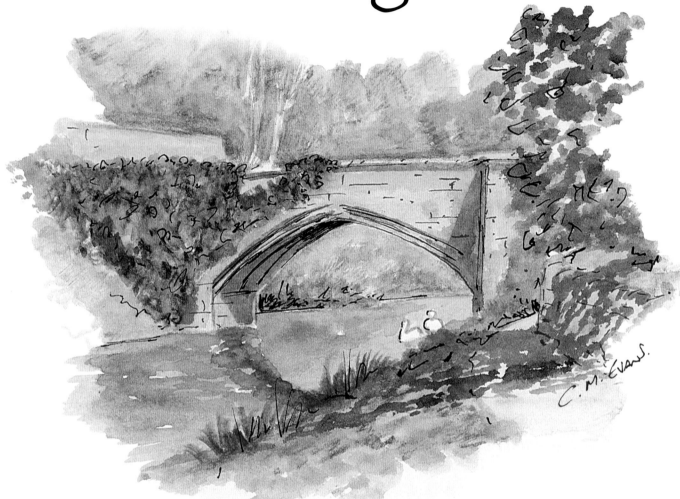

This lovely old ivy-clad bridge, with swans on the river beneath and trees coming down to the river banks, is a favourite subject for artists. But this is a classic example of 'editing' with your eye – in fact, there's a horrible new bridge right behind this one, with ugly pillars visible, in real life, so I just left them out and continued the grass and trees through the bridge.

I used cool grey pencil for the initial drawing on sketchbook paper, starting with some bumpy lines for the ivy. I put the pillars in and made a mark for the centre of the arch, then just made a few guide marks for the trees and swans.

1

I start by scribbling yellow ochre on to the front part of the bridge, once again just colouring in like a child's drawing. I use more pressure on the right-hand pillar, and a little less for the one on the left.

2

To knock back the brightness of the ochre I gently stroke cool grey, the colour of the outline drawing, over it...

3

... and then go in more strongly with the grey underneath the arch. I also make sure to draw the shadow line at the bottom of the left pillar.

4

For the trees behind the bridge I use broad strokes of sap green, keeping the strokes light in the background, and stronger as the trees came closer...

5

... these trees act as a frame for the bridge, making them stand out, so I also use short strokes to give the feeling of a blaze of colour.

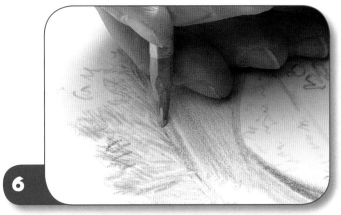

6

To enhance the trees I go in strongly with cadmium yellow, again using short strokes among the green and not attempting to cover the whole area.

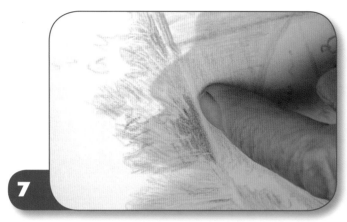

7

I then switch to Prussian blue, first using this at the base of the trees, making sure to leave a sliver of white between this colour and the top of the bridge...

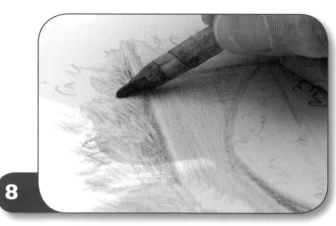

8

... and then go into the trees themselves very sparingly, just to suggest some darker shadow areas in the woods.

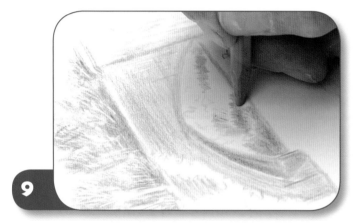

9

Staying with the Prussian blue, I put in the continuation of the bank seen through the bridge arch, and then add sap green and cadmium yellow, each time working slightly more strongly than above the bridge.

10

For the ivy I use a heavy-duty green, Hooker's green, scribbling it on and leaving some patches of white paper showing through. Although I'm basically colouring in, I use very small, curly marks...

11

... and follow these with similar marks of Prussian blue and blue-grey to add depth and suggest a mass of ivy that stands out from the pillar.

12

Even with these darker blues I want more darks in the ivy, which I put in here and there with Mars black. A few strokes of sap green to the left of the ivy, and that's the first part of the drawing done.

13

There's hardly any sky in this scene, so no fabulous washes this time! I use a light wash of ultramarine blue, taken off the pencil with a No. 8 brush, and making sure to go into the trees; and then I use clean water to lift off the pencil and suggest the shapes of some trunks.

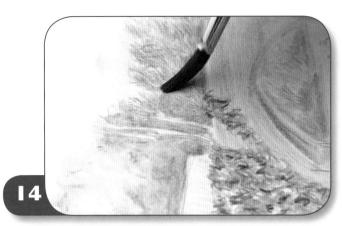

14

I don't use as much water for the rest of the background trees as for the trunks – just enough to merge and soften the colours to give an overall impression.

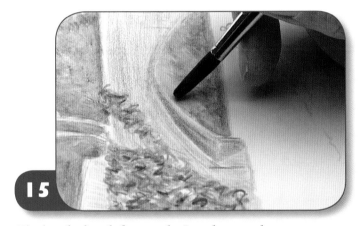

15

Rinsing the brush frequently, I stroke over the area beneath the bridge, taking the colour up to the arch. This now needs to dry completely before I go on to the main character of the picture – 'focal point' sounds stuffy, and this bridge has a character of its own.

16

Now I wet the bridge, a simple task of stroking water over the colour; the cool grey dulls the ochre a little, making sure that it's not too bright...

17

... and I go from that to the underside of the arch, working carefully so that these darker areas don't spread into the lighter ones.

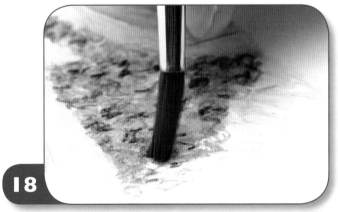

18

For the ivy, having spent time putting on the colours with the pencils, I don't want to spoil this, so I merely dab the brush on, melting and merging and leaving some parts dry and with harder edges. A few dabs for the grass, and that's that part done for now.

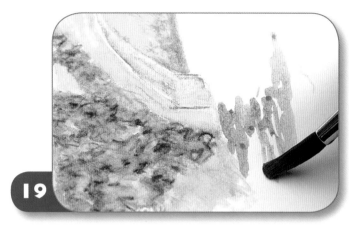

19

Time for the river – I'm going to start with the reflections, as I can't go back and add them later. I start with yellow ochre and blue-grey mixed on the brush, a bit darker than the colour of the bridge, and put this on with short, rounded brushstrokes to show movement.

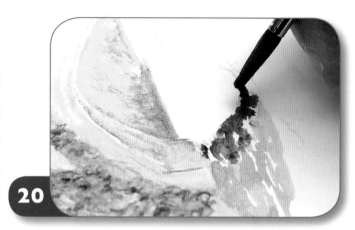

20

For the darkest reflections I use Mars black, again leaving some white among the brushstrokes...

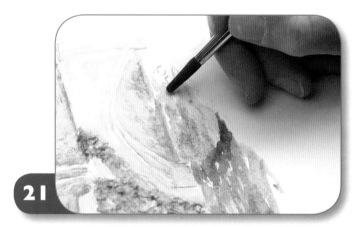

21

... and follow this with a mix of sap green and blue-grey for the reflections of the trees. For the rest of the river I make sure there's no green left on the brush and then use a wash of blue-grey, painting around the outlines of the swans; I add a touch of raw umber at the bottom of the bridge.

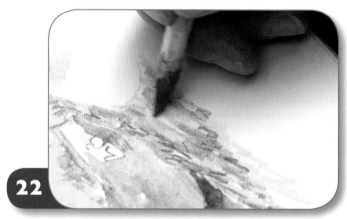

22

Moving on to the right-hand bank, I start with strong marks of cadmium yellow and then Prussian blue, each time using the side of the pencil. I also put in a few short, curly brushstrokes of Hooker's green...

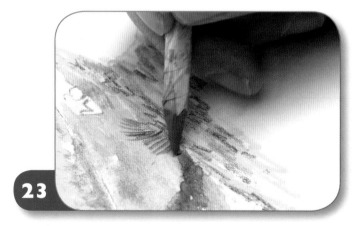

23

... and then use this colour for some sharp grasses at the river's edge – just a few, as I don't want to distract attention away from the bridge.

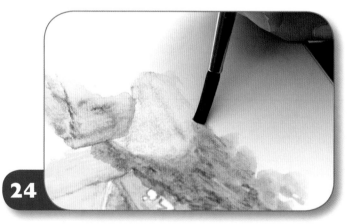

24

Now I put a wash of clean water over all of this – the three colours give a great deal of variety in the grasses. After letting this dry, I add the path with a pale wash of blue-grey, stroked off the pencil with the brush.

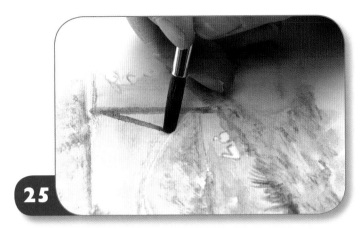

25

It's a bright, sunny day, as you can see from the photo below, so I add strong shadows on and under the bridge with permanent magenta taken off the pencil. The ivy casts shadows, as does the parapet.

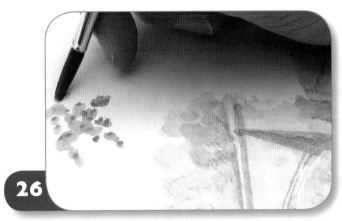

26

For the leaves on the right side, I mix a dark wash of Hooker's green and blue-grey on the brush and simply tap this on. Now all the other trees instantly drop back, and you can see the sky through the gaps in the green.

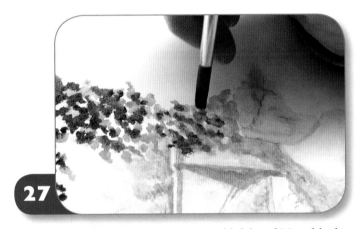

27

To give more framing in this tree, I add dabs of Mars black, working in the same way and making sure to leave the sky showing through the foliage.

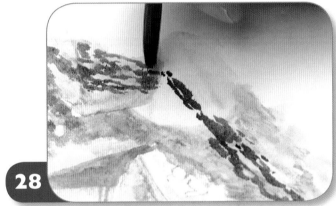

28

The shadows from this right-hand tree are very dark, so I mix Mars black and permanent magenta on the brush and dot this on for a dappled effect. Even when this dark, the shadows are slightly lighter the further away they are.

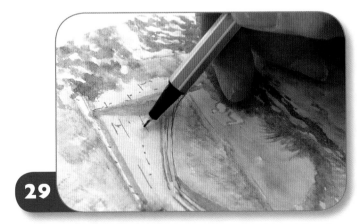

29

With everything dry, I add the finishing touches with a fine black fibre-tip pen: a little stonework on the bridge and a bit of work on the ivy and on the banks and trees. I go in quite strongly on the underside of the arch, to reinforce the curve – and that's it.

sketchbook: landscape

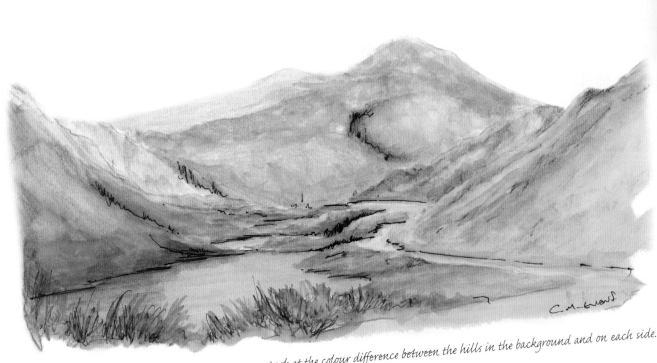

Look at the colour difference between the hills in the background and on each side.

These Highland cattle are mainly watercolour pencil washes, with just a little penwork.

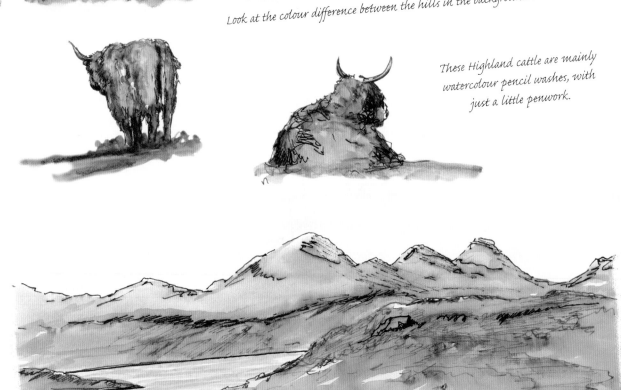

By not putting in a coloured sky, you can concentrate on the colours of the hills themselves.

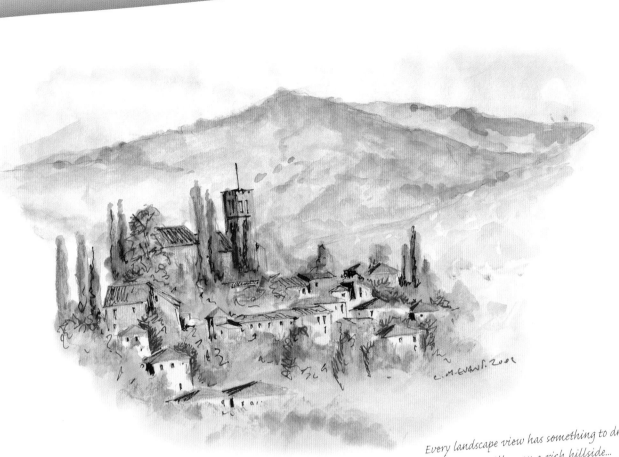

Every landscape view has something to draw, from a village on a rich hillside...

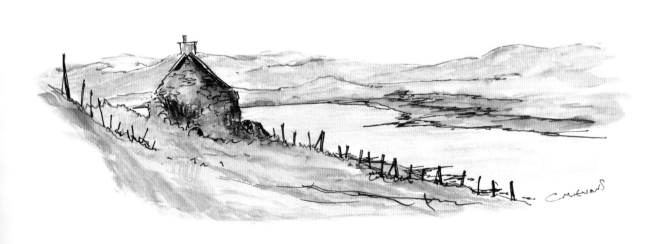

... to a bleak but impressive lakeside scene.

Classical Life Study

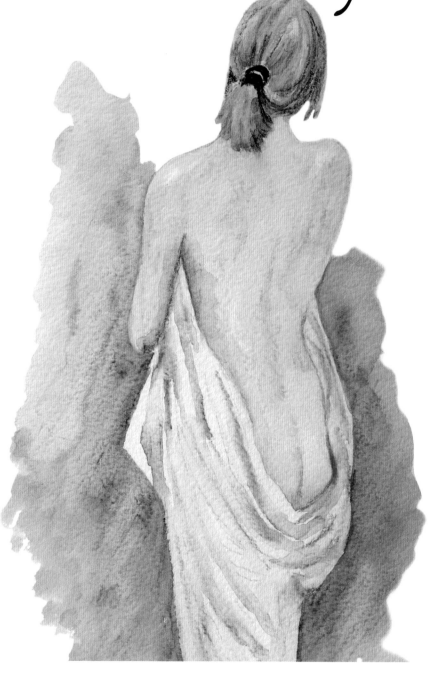

Life studies seem scary to a lot of people, and for this reason they don't attempt to draw or paint from life. But as a landscape painter myself, and one who doesn't usually concentrate on the human form, here's a tip – just think of the body as yet another landscape: there are dips and valleys and mounds and, if you're very lucky, occasional flat bits. Think of it in this way, and there's no need to be scared.

By way of getting started, I make a simple outline drawing with light grey, working on blue-tinted Bockingford watercolour paper. Using this colour pencil means that once I apply water, the outlines disappear.

This is what's called negative drawing, where I start by dropping in the background behind the model. I literally just scribble on blue-grey, taking care not to go over the outline of the body...

...and follow this with a little Vandyke brown on top of the blue, again stopping at the outline. This is one of the advantages of pencils – it's a lot easier to stop at a certain point than it is with watercolours.

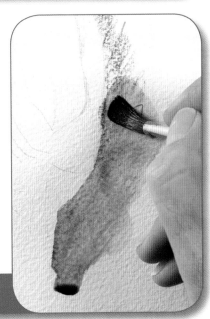

I then use a No. 8 round brush to stroke clean water over the background colours, merging and blending them together to make a lovely soft, out-of-focus backdrop.

This is what I meant by negative painting; and it's not difficult to imagine that this is a landscape – how many times have you worked on the sea and sky, say, before putting in the land in the middle? Well, that's how I'm working here.

Once the background is totally dry I start on the model. First I work on the hair using yellow ochre, making long, curved strokes that follow the line of the head; then below the hair band I use shorter strokes.

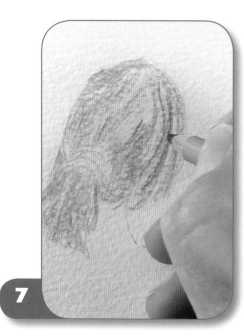

Hair is never one single colour; I add a few strokes of Vandyke brown to the yellow, again being careful to follow the lines of the head.

7

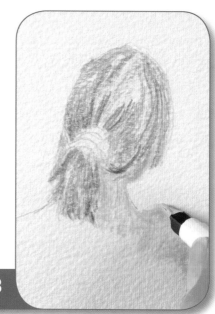

Like hair, skin tones are different across the body, so although this next bit is like filling in the spaces, I keep a close eye on the variations and differences. I start with a flesh tint light pencil at the neck...

8

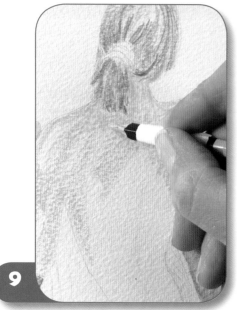

... and as I go down the back, I alternate this with some flesh tint dark. The pencil strokes catch on the top of the watercolour paper, leaving patches of the tint showing through and stopping the colour from becoming too solid.

9

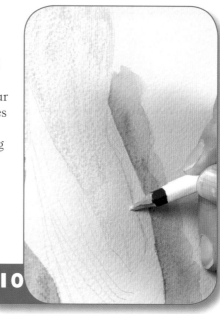

As I go down I'm careful not to go over the robe with the skin colours, working just up to it.

10

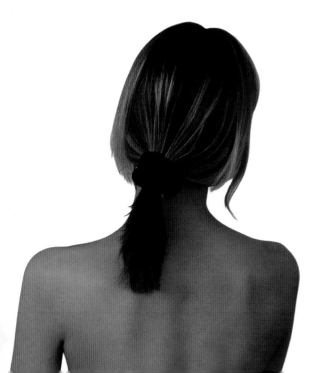

I'm doing all the hard preliminary work now – for shadows I use blue-grey, working the pencil quite strongly into the larger shadow under the arm...

11

... and much more lightly along the backbone, where the shadows are smaller and less distinct.

12

As I put in the shadows I'm still looking at the skin colour, and add a few light strokes of light red for warmth.

13

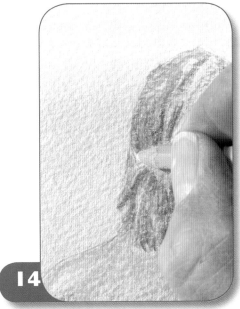

With white paper, I use the paper colour for highlights; on tinted paper, I use a few touches of titanium white instead. That's the drawing done, and it's time for the magic...

14

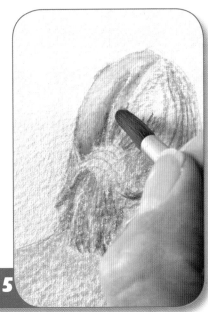

... which, of course, is water! Using a No. 8 round brush and clean water, I stroke into the hair, again following the line of the head.

15

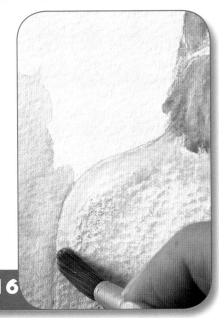

After thoroughly cleaning the brush I work on the body, using quite a bit of water to soften the colours.

16

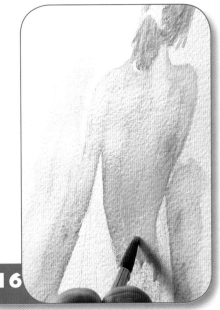

As I go down the arm and then the back, I concentrate on the direction of the brushstrokes and the contours of the body.

16

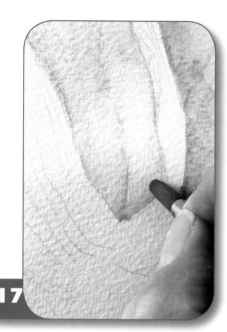

I rinse the brush regularly so that I can pick up the areas where the blue colours were drawn on strongly, and use this extra colour for contrast with the rest of the skin tone.

17

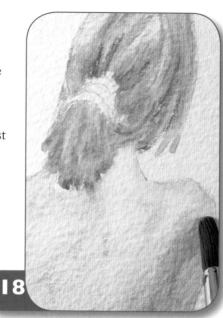

Even though the colours are made more solid with the water, the texture of the paper still allows the tint to show through.

18

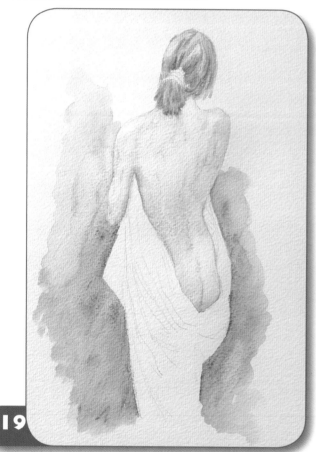

19

That's the body completed; now I can take a look at the last large bit of negative space – the robe – with the tones I need set by the skin and the background.

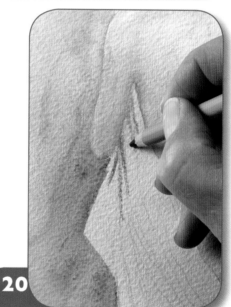

As we all know, white is not white – at least not in the shadows, folds and creases – so I draw these in with blue-grey. I'm not trying to get in every fold, but to follow the contours of the robe as it hangs from the body, as well as where the two meet.

20

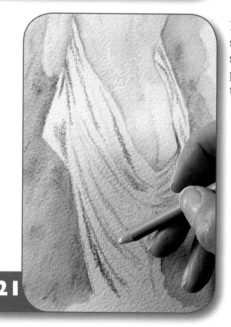

For the lighter and shallower shadows I switch to a light blue pencil, again following the folds.

21

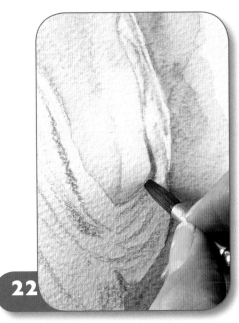

When I put on the clean water, the darker blue-grey gives me deep, emphatic shadows, such as where the robe meets the body...

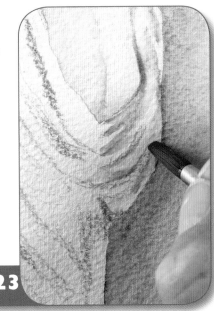

... while the light blue gives paler shadows on the surface of the robe. The main thing to look for here is the direction and swirl of the fabric around the body beneath it.

There are just a couple of things left to do now. I colour the hairband quite strongly with a Mars black pencil, leaving some tiny specks of the titanium white I put on earlier as highlights...

... and use the same pencil, only this time very lightly, to put some more shadow below where the arm meets the body. I then use a lot of clean water on this part to add just a hint of extra shadow.

The finishing touch is to use a small amount of water to solidify the hairband, again leaving the white as highlights. Against the rest of the colours, this area now stands out strongly. And that's my classical life study done.

sketchbook: Buildings

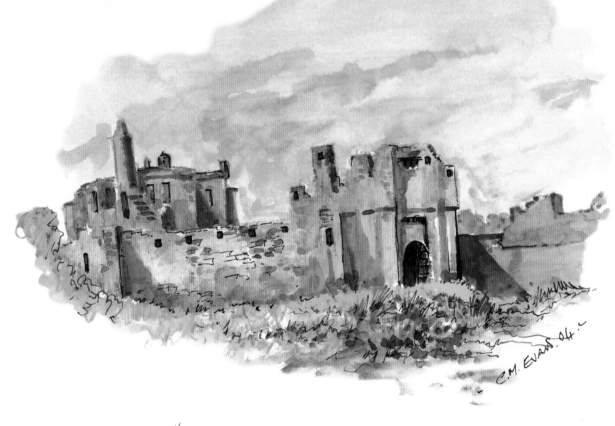

From a ruined sandstone castle...

...to a detailed doorway in shadow...

... and from somewhere really quite well-known...

C.M. EVANS. 07.

... to somewhere quite secluded, there is always something to sketch.

People in Paris

For this next project, I thought it might be an attractive idea to nip briefly over to Paris in the springtime – in particular, the Champs Élysées (and if you haven't been to Paris in the springtime, why not?). As with any urban scene, including people makes a picture come to life, and there's the hint of a café in the distance.

I used cool grey pencil for the initial drawing on oatmeal-tinted sketchbook paper; I concentrated on getting the steep angles of the buildings on the right correct – the people and cars were no more than blobs and shapes at this point.

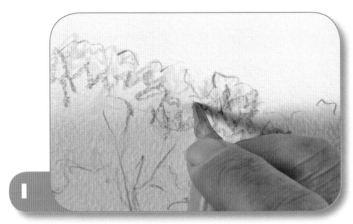

1

For the spring colours in the nearer trees I start with cadmium yellow, and follow this with some olive green. I make the pencil marks quickly, just sketching in the colours and not giving myself time to fiddle about.

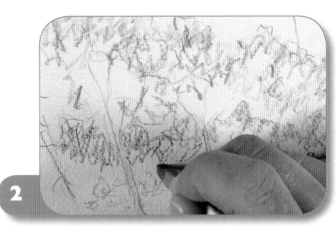

2

I then put in a few touches of Prussian blue for the trees on the other side of the road; again, the more detail, the stiffer and tighter the result, so I keep everything spontaneous and full of movement in the marks that I make.

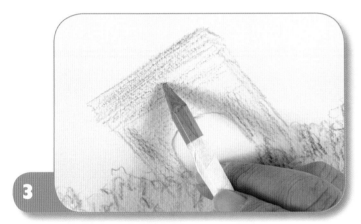

3

The base colour for the Arc de Triomphe is the same cool grey I used for the outline drawing; I then warm this up with a little light red, still drawing quickly and boldly, and not attempting to put in details.

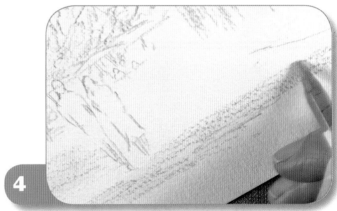

4

I use the same grey and red for the other buildings in the scene, working along the steep diagonal angles. After adding a little yellow ochre there, I use this colour for the pavement, making horizontal strokes that don't cover the whole area but let the paper show through.

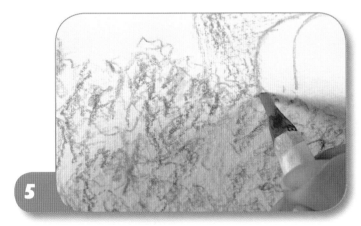

5

After adding a bit of yellow ochre into the nearer trees, I then use a stronger, darker green: viridian – this is a powerful colour so I use it sparingly, otherwise it can easily take over an area.

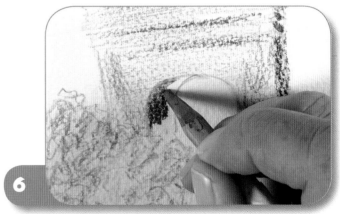

6

Switching to blue-grey, I use this pencil very strongly underneath the arch of the Arc de Triomphe and for some cast shadows under the trees...

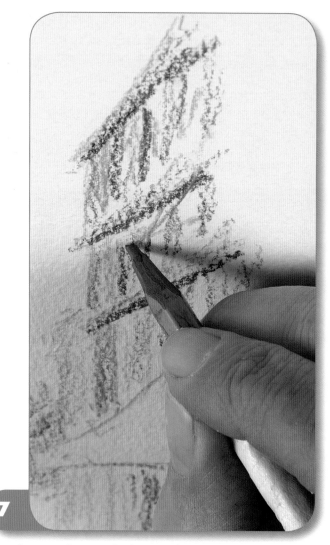

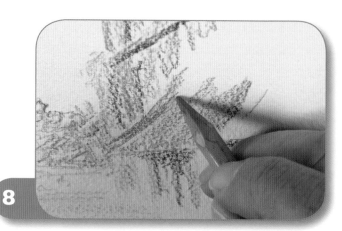

I use a little cadmium red to start the awnings on the building, then a lot more light red over it, to cool it down...

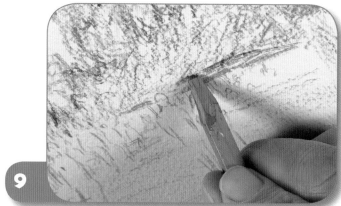

... and to put the cast shadows and recesses into the right-hand buildings as well.

... and then use cadmium red on its own for the parasols by the café – I draw these as a set of lines and squiggles, not putting in any detail or separation, as they are quite a way in the distance.

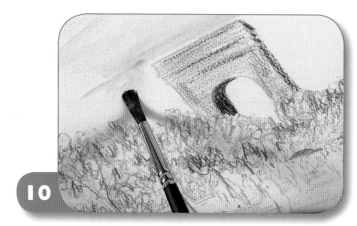

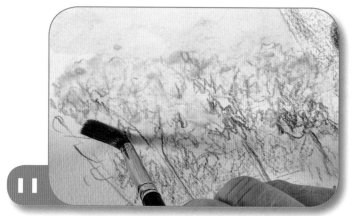

For the sky I take manganese blue off the pencil with a No. 8 round brush and just swirl it on to the paper; the sky needs to be noncommittal and simple, as there's plenty going on lower down the paper.

While the sky is wet, I use clean water to merge the tops of the trees, coming down into the darker, shadowed areas.

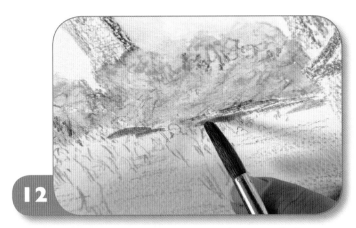

12

I clean the brush and drop water into the parasols, just wetting them and not moving the colours around.

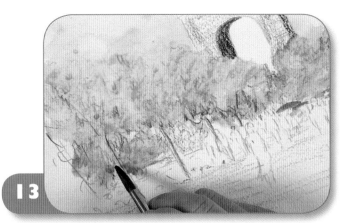

13

Then, again with a clean brush, I dab water onto the Prussian blue of the trees in the distance; any variations in tone add interest to this background area.

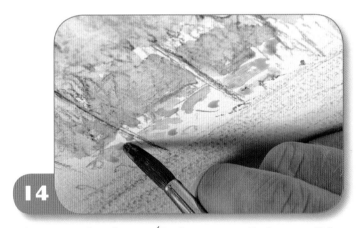

14

The cars on the Champs Élysées are next: I take some light blue of the pencil with the brush and put a few simple dabs of colour on the paper...

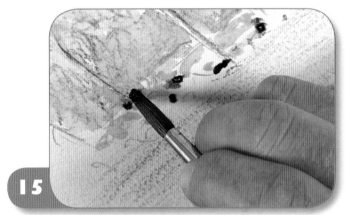

15

... followed by even fewer dabs of Mars black – the simpler the application here, the better the impression of movement, texture and vibrancy.

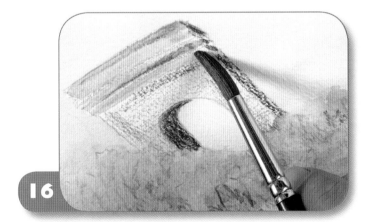

16

I start painting the Arc de Triomphe by dropping clean water into the light side, using brief strokes of the brush in order to get a warm, airy feel. I then repeat this on the darker side.

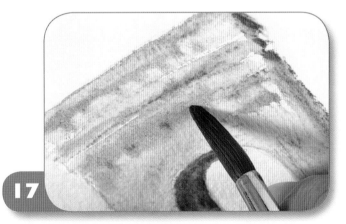

17

After wetting the dark underside of the arch, I lift off a little of the colour and use it to put some architectural detail into the still damp wash on the front. The colours merge and soften, giving just an impression, rather than stark detailing.

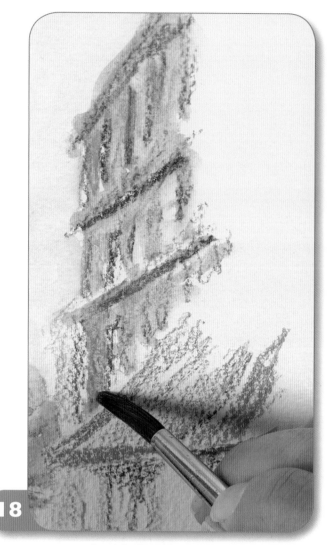

18

I now move on to the right-hand building, where I wet and merge the colours, being careful to leave some of the pencil marks untouched as hard edges.

19

While the trees are still damp, I tap dry sepia pencil over the wash; I then wet the trees with a little water before setting to work with the pencil again...

20

... and to move the colours around without putting on too much water, I use my finger, cleaning it between each time I apply it.

21

At the bottom of the trees in the centre I put blue-grey pencil dry into the damp wash, to create depth and definition; I use the texture of the paper to get texture in the edges of the tree trunks.

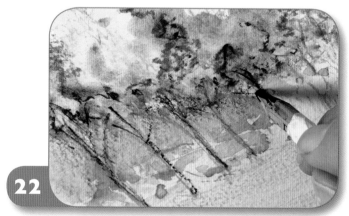

22

Moving back to the left-hand trees, I put strong strokes of yellow ochre on to the trunks, and follow this with Mars black, using the tip of the pencil to draw the shadow sides and a few larger branches.

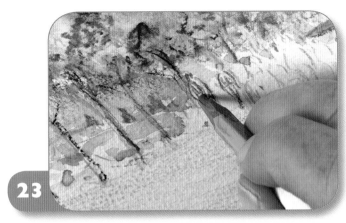

23

I start drawing the people with those in the distance, using blue-grey and a selection of browns and Mars black. At this range they are just blobs – some shorter blobs sitting at cafés, and some silhouetted blobs by the cars.

24

For the nearer figures, I go in hard with a selection of pencils – titanium white, orange, manganese blue and Mars black – with a few touches of both light and dark flesh tints for skin.

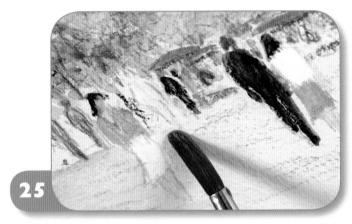

25

Cleaning the brush between each colour, I dab on clean water to solidify the colours of the people. When they have dried I go into the pavement areas, working carefully between the figures.

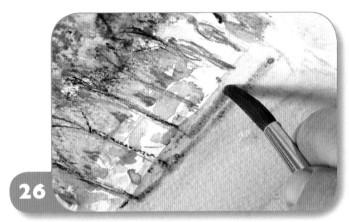

26

While this wash is wet, I put in the cast shadows with permanent magenta on the brush: these are cast by the trees and people, and are also on the buildings and creating contours on the pavement in the foreground.

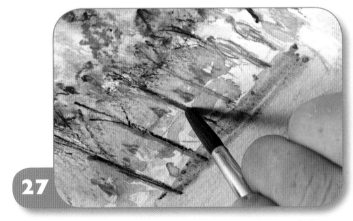

27

As I put the shadows under the nearer trees on the left, I also lightly stroke the magenta down the shaded sides of the tree trunks, enough to just move and merge the black with the new wash.

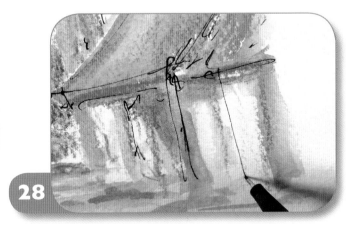

28

When everything is dry I move to a fine black fibre-tip pen to put in the final touches – quick, loose strokes for the windows and on the buildings, and some rounded, curly lines to pull it all together, with some more suggestions of background figures. Et voilà – April in Paris.

Moors and Hills

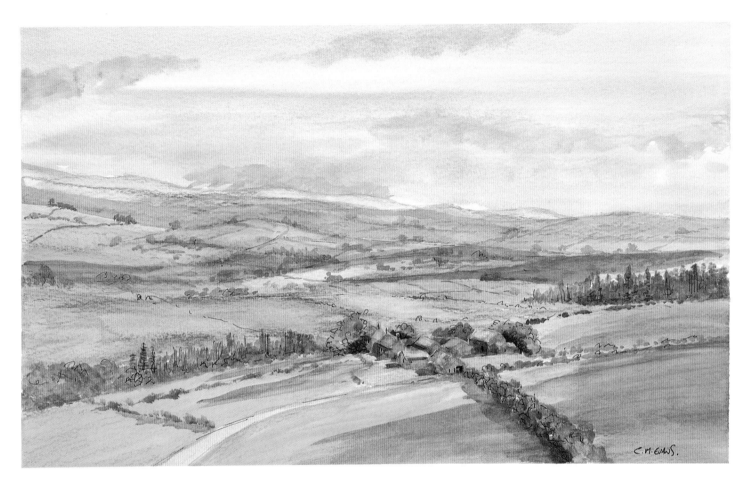

I started the projects in this book with a simple moorland scene, and now it's time to come full circle – this is a view of Alnwick Moor, said to be one of the late Queen Mother's favourite spots in England. When you come to a big vista like this, you can't put everything in, so pick a portion and focus on it the way you would any other landscape. Here we go...

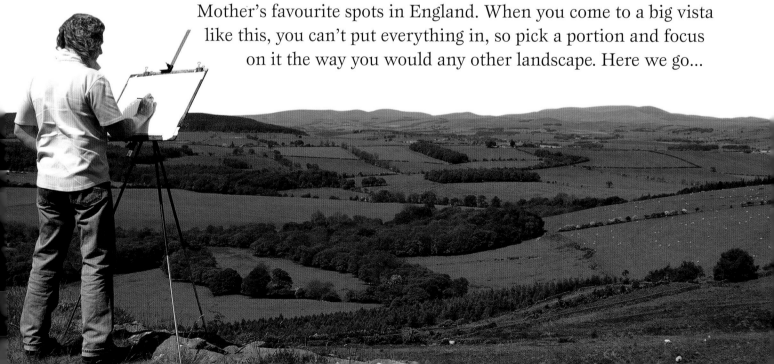

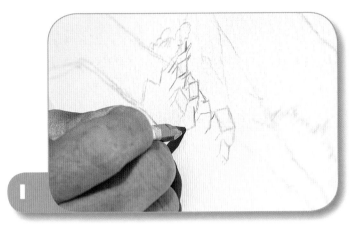

Working on Langton Rough watercolour paper, I make the initial drawing in cool grey: the pine forest is zigzag scribbly lines, and I draw in the outline of the splash of light on the far fields. Because I'm looking down on the farm, the roofs of the buildings slope diagonally upwards slightly to give the feeling of recession.

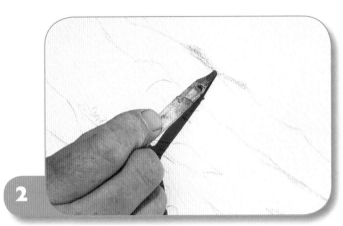

With the outline drawing done, it's time to start adding the colour; in the far distance I put on a little Prussian blue and, just like in the first moorland project, I scribble the pencil over the paper, like in a child's colouring book.

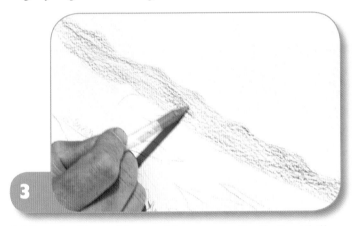

I follow the blue with some blue-grey on the furthest hills, then add some burnt sienna and raw umber for the darker, bracken-covered parts. In addition to putting the colours onto the white paper, I push them into the other colours, to merge when I add water.

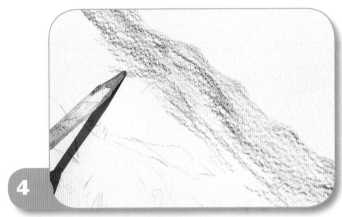

As I come forward into the middle ground I switch to Hooker's green, scribbling it in and stroking it on to fill up the paper – the rough nature of the paper ensures that the white will show through a little below the textured bumps on the surface.

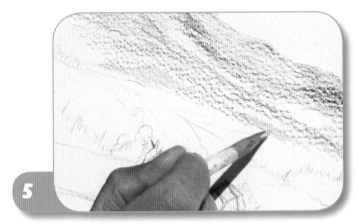

There are some fields of bright oilseed rape among the green areas, and I use cadmium yellow for these. Then I go over some of the green pencil marks, not trying to cover them but giving opportunities for blending later.

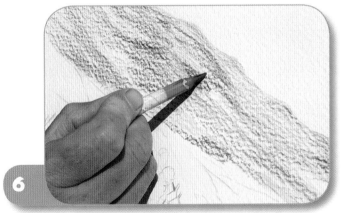

In the same way as with the yellow, I go over some of the Hooker's green with blue-grey, to darken and tone down the furthest fields and introduce a cool colour.

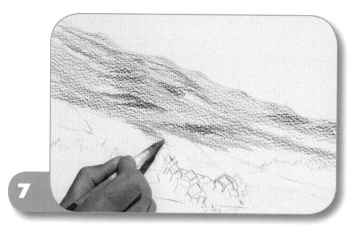

7

Coming further forward again, I use yellow ochre for the fields leading to the farm; so far I haven't drawn a single tree, apart from some patches of woodland, as going into such detail would bog me down – a few blobs here and there will do for now.

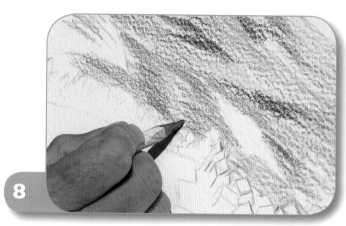

8

For the field immediately above the farm, I start with sap green, then warm this with yellow ochre and darken it with Hooker's green, working the colours into and over each other as a basis for applying water. I then fill in the bare patch with cadmium yellow. What a mess.

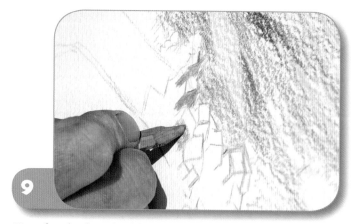

9

Now for the farm buildings: I start by filling in the sides facing the light strongly with yellow ochre...

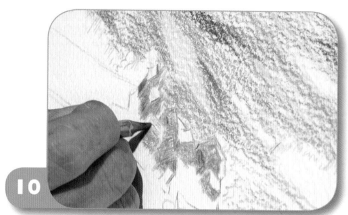

10

... and then use raw umber for the darker sides. I use cool grey for the nearest building and burnt sienna and blue-grey for the roofs. The farmyard is a mix of yellow ochre and blue-grey.

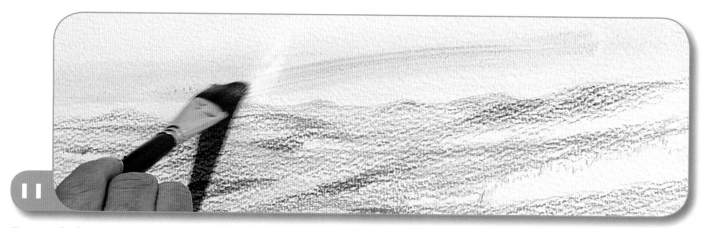

11

I've nearly finished the drawing part: the fields on this side of the farm are the same blending of cadmium yellow followed by Hooker's green, over and beside the yellow. I haven't filled in the plantation forests yet, but now it's time to go into the sky.

This is a big piece of paper, so I use a ¾ in flat wash brush to wet the sky area with clean water, then use the same brush to take yellow ochre off the pencil and paint it into the bottom part of the sky; the water helps this wash spread and flow.

12 Next I put Prussian blue into the top of the sky in the same way – working quickly, just as with a watercolour painting. As the colours bleed together I add some blue-grey for the darker blues in the sky; any bubbles in the paint will go as the colour dries.

13 While the sky is damp I stroke clean water into the Prussian blue at the top of the distant hills, so they soften into the base of the sky. Let there be light! I leave everything to dry for a while.

14 Now it's time to reap the rewards of all that drawing – I merge the colours of the distant hills with clean water, producing lovely bracken colours as the ochre and blue-grey blend together.

15 As I carry on into the green areas, I bring the brushstrokes down to follow the lines and contours of the fields, and even leave some parts dry so the texture of the paper shows through. I stop at the top of the farm buildings for now.

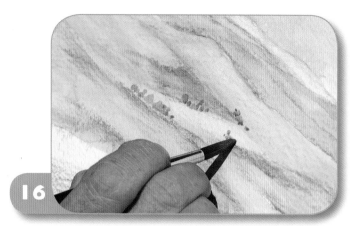

16

Moving back into the middle distance, I use mixes of blue-grey, Hooker's green, permanent magenta and Prussian blue, taken off the pencils, to put in some lumps and contours. I then drop in blobs and dots for trees, using a No. 8 round brush and mixed blue-grey and Prussian blue.

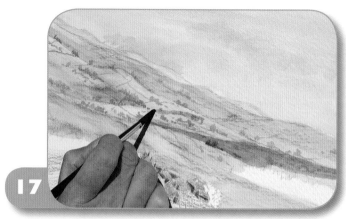

17

The basic washes on the fields are now dry, so I use permanent magenta to put in great swathes of shadows cast by clouds across the landscape.

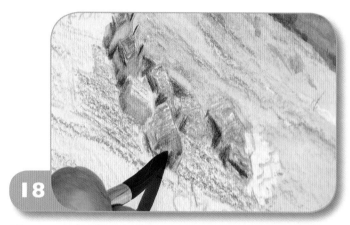

18

Next I wet the farm buildings, working very carefully and remembering to keep the lighter parts as I drew them...

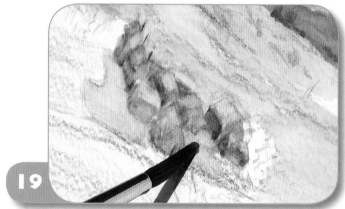

19

... and then I go into the farmyard and merge the pencil marks there, before letting the whole area dry.

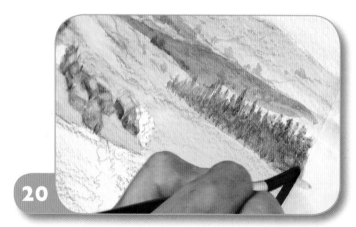

20

For the plantation on the right I make a good strong mix of Hooker's green and blue-grey, taking the colours off the pencils with not a lot of water on the brush. I tap in the tops with the brush point and use the side further down.

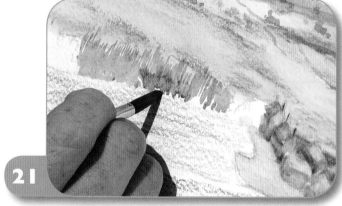

21

I use a slightly lighter version of the mix for the tress on the left, and add some cadmium yellow to the green mix for the trees nearest the farm, to add contrast and depth.

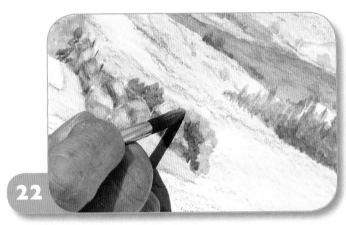

22

For the deciduous trees that border the farm I start with Hooker's green, then add permanent magenta at the base, particularly where the trees meet the buildings. While the green is wet I dab some cadmium yellow into the top parts.

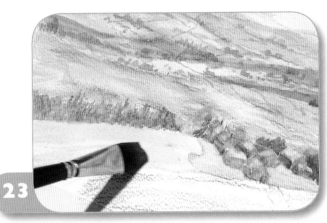

23

Switching back to the flat wash brush, I fill in the foreground fields with big broad strokes of clean water. I take these washes up to the plantation trees, leaving the hedges as white paper.

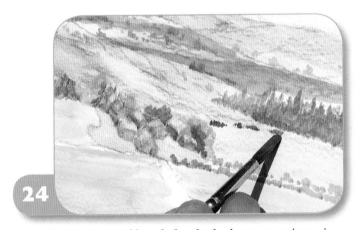

24

I use the No. 8 round brush for the hedgerows, using mixes of Hooker's green, sap green and blue-grey and making sure that the colours are stronger in the foreground than further away. Even as I fill these bits, I leave tiny bits of paper uncoloured to catch the light.

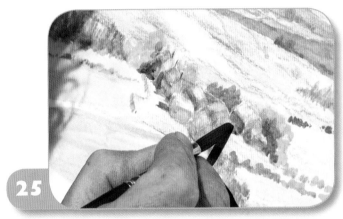

25

I use permanent magenta for the shadows: among the buildings, cast by the hedges and, using the wash brush, a great sweep across the foreground – the more shadows, the more light. After filling in the track with blue-grey, I let everything dry.

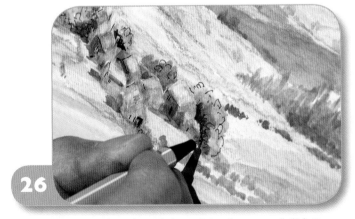

26

By now I'd put a lot of work into this picture and didn't want to overcook it, so I kept the final touches to a minimum: using a fine black fibre-tip pen, I put a few squiggly bits on some trees and tightened up lines on the buildings. Who says watercolour pencils aren't versatile – you can take them anywhere and get great results!

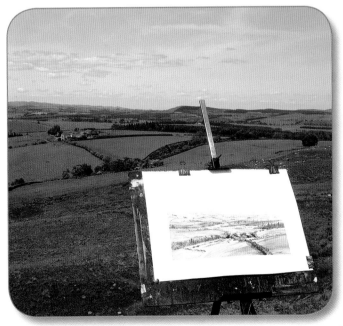

Moors and Hills 119

index

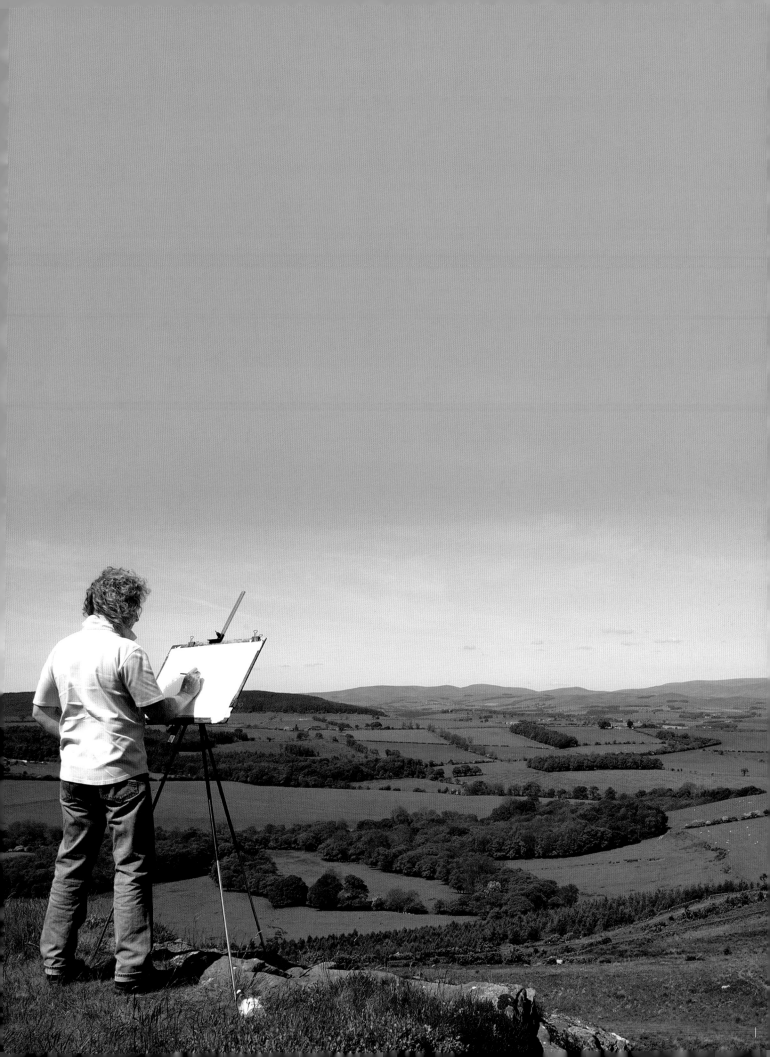